JAPANESE COMICKERS

Draw Anime and Manga Like Japan's Hottest Artists

This Book is Presented to
The Clayton Community Library
by the

Clayton Valley Sunrise Rotary Club
in Honor of our Guest Speaker

Deri Kasper

1/4/07

date

A DEX BOOK

2003 © DesignEXchange Company Limited

This book is conceived and produced by
DesignEXchange Company Limited
Nakameguro GS Dai2 Building
2-9-35 Kamimeguro Meguro-ku Tokyo
153-0051 Japan
Phone: +81 3 5704 7374 Fax: +81 3 5704 7354
e-mail: intl@dex.ne.jp
http://www.dex.ne.jp

First published in English by:
Harper Design International, an imprint of HarperCollins Publishers
10 East 53rd Street
New York, New York 10022–5299
Fax:212 207 7654

ISBN 0-06-051355-1

Distributed throughout the world excluding Japan by:
HarperCollins International
10 East 53rd Street
New York, New York 10022–5299
Fax:212 207 7654

Contributing Artists: Yu Kagei, Hiroshi Fujiko, Nanamirio, Noriko Meguro,
Shunpei, Hinoki Amamori, Sunaho Tobe, nini, Hikaru Nakano, ridoru, Ryuya,
Yoko Tanji, Mey Suzuki, and Ippei Gyoubu
Text: Kengo Hirasawa
English Translation: Linda Yabushita & Rico Komanoya
Editing and Coordination: Yuri Okamoto
Editorial Coorporation: Keiko Yamamoto (Bijutsu Shuppan Sha)
Cover and Book Design: Katsuya Moriizumi
Book Concept and Production: Rico Komanoya

Artwork credits appear on page 125.

Printed in China by Everbest Printing Co., Ltd.

Second Printing, 2003

JAPANESE COMICKERS

Draw Anime and Manga Like Japan's Hottest Artists

edited by DesignEXchange

HDi

HARPER
DESIGN
international

An imprint of HarperCollins Publishers

CONTENTS

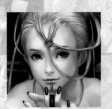
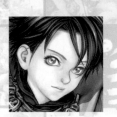
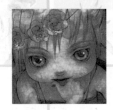

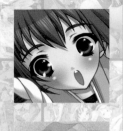

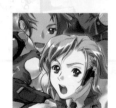

INTRODUCTION

Production efficiency and schools of manga and anime drawing

Historically, the expressive forms known as manga and anime that have developed within artistic culture are considered to be mutant and irrelevant. However, adding commercial productivity to the equation allows us to consider the schools of manga and anime in a fairly linear way.

Let's take a look at the path the *otaku* culture of manga and anime has traveled, with the keyword "production efficiency" to help us unravel the various schools of drawing styles that have grown up within this unique culture.

From cartoons to manga

Japanese manga originated from imitations of American cartoons (a term used here for the sake of convenience). A type of comic *ukiyo-e* picture specific to Japan called *kyoga* (crazy picture) was, of course, already in existence. But these pictures, made with the *suri-e* technique of printing with woodblocks, were troublesome and time-consuming to produce, so, unable to keep up with the requirements of modern publishing, they eventually died out.

Originally, Japanese manga drawings were often simplified in order to improve production efficiency. This was in stark contrast to the high quality of American cartoons, which had the luxury of time because they were run comparatively infrequently, in the Sunday edition of newspapers, for example. Manga carried in the regular daily papers were monochrome and employed a variety of pen illustration techniques such as hatching and cross-hatching to express depth and shading.

Mass production, prerequisite to the active promotion of simplified and stylized drawings, gave rise to the phenomenon of "rental manga." Published on a monthly basis, rental manga averaged about 100 pages and contained complete stories. The Japanese manga came into its own as a mass consumption product.

Anime and the advancement of stylization

When anime came to be mass-produced in the period from the late 1960s to the mid 1970s, a distinctive style of figure representation emerged from the simplified anime formula of Japanese limited animation. Unlike full animation, which uses 24 frames per second, Japanese limited animation uses a substantially lower number of only 8 frames per second, so movement tends to be awkward and unnatural. Yoshinori Kanada and other talented animators compensated by devising techniques to make movement appear more fluid, such as "pulling" or "holding" still images in the instants between movements. Thus, stylization of motion followed on the heels of picture simplification and stylization.

As these techniques were developed and still pictures were given an increasingly large role, the focus shifted to quality. To improve the appearance of individual pictures, shading began to be incorporated in the cel painting process—a technique not often seen in Disney animation. This was the start of what is popularly referred to as anime-style drawing.

The age of realism

Later, as animation technology evolved, human and animal figures rendered with anatomical precision, and coherent

Koji Morimoto's representative works "Noiseman"
© Beyond C./ BANDAI VISUAL

mechanical gadgetry appeared on the scene.

As "real mecha" animators Ichiro Itano, Hideaki Anno, and others reached their zenith with a genre of realistic robot animations, of which *Gundam* (aka *Mobile Suit Gundam*) was the first, character representation—in particular, the increasingly sophisticated use of shading to achieve three-dimensional effects—began to keep pace with the new mechanical realism. It was during this period that two- and three-layer gradation painting to represent curved surfaces on human figures, and other techniques for achieving non-two-dimensional appearance became entrenched in anime production.

Although character appearance and coloring moved in an increasingly realistic direction, formative expression was dominated by non-anatomical anime-style drawings featuring charac-

ters with huge eyes and flat faces, exemplified by the illustrations of Tsukasa Dokite, Yuji Moriyama, and Haruhiko Mikimoto. The end of the 1980s and Japan's bubble economy saw the emergence of several animators who were acclaimed for their portrayal of realistic character form, among them Yoshiyuki Sadamoto (*The Wings of Honneamise*; aka *Royal Space Force*), and Takashi Nakamura and Koji Morimoto who directed animation for the film version of *Akira*. However, popularization of this type of character rendition was prevented by the high level of artistic skill required and also by budget limitations.

Anime and manga: An indistinct border

The development of realism in anime hit the world of manga beginning in the late 1970s. Refinement of the drawing style of French *bande dessinée* (comic strip) artist Jean Giraud Moebius, and incorporation of a cinematic layout of manga panels for purposes of visual impact and contrast—using large panels to emphasize climactic moments, for example—enabled the sort of extreme realism epitomized by Katsuhiro

Utena
©Be Papas. Chiho Saito. Shogakukan. shokaku linkai. TV Tokyo
© 1999 Revolutionary Girl Utena

Otomo's *Doniu* and *Akira*.

Counter to Otomo's style of elaborate hand-drawn hatching and cross-hatching done with round pens and other precision drawing instruments, was the ample use of screentone to add texture, depth, and atmosphere—a technique which developed rapidly. Screentone became an indispensable tool for manga artists such as Masamune Shiro who do anime-style drawing, because the technique makes the type of nuance seen in animation cels possible in the monochrome world as well. Additionally, because screentone does not require the high level of technical expertise and amount of time that finely detailed drawing does, it can be relegated to assistants, and thus is a great convenience for the artist who must be concerned with efficiency exacted by the constraints of serialization. By the mid 1980s, screentone had become a standard technique in the manga world.

Return to simplicity?

As we have seen, manga and anime drawing evolved in a sophisticated and complex direction. Then, in the 1990s, the public appetite reverted to a preference for simple drawings. The collapse of the bubble economy has been offered in explanation for the new focus on efficiency and elimination of the increasingly complex drawing and painting techniques that were engendering rising production costs, although this claim

The most typical example of gal pictures, the artwork by Nini (see pages 66-73)

© enterbrain 2002 MAJIQ PREMIUM SPRING 2002

is unsubstantiated.

Shinya Hasegawa, well-known as the animation director for *Evangelion* (aka *Neon Genesis Evangelion*) and *Utena* (aka *Revolutionary Girl Utena*), points to the use of deformation in drawing to express, to a certain degree, three dimensions within in a two-dimensional environment, as being responsible for the demise of the style of painting used for anime produced in the mid 1980s. He argues that even if the advancement of production techniques is disallowed, the minimal resistance met by marketing of anime character figures is sufficient evidence of this.

Character drawing

Digitalization swept into the anime and manga worlds at the close of the 1990s, producing several new strains, including adult-oriented *bishoujo* (pretty young girl) computer games, and "gal pictures," a phenomenon that arose as a specialization of the efficient processing possible with image-editing software such as Adobe Photoshop.

This trend has had exactly the reverse effect on manga and anime drawing of that described above by Shinya Hasegawa; it has made the 3D figure rather than the picture the starting point. Unlike conventional character depiction, which deforms form and expression to achieve a three-dimensional appearance, gal picture drawing starts with the three-dimensional figure and turns it into two dimensions—a style that has enjoyed explosive popularity along with the proliferation of digital tools. Helped along by an abundant supply of examples and the unrestricted nature of drawing techniques, gal pictures carry heavy clout in the *doujinshi* market, which can be described as the "indies scene" of manga.

...Towards more variation

The expressions of Manga and Anime have developed in a variety of ways and have become a kind of "Life Tree" that extends its unique branches in multiple directions. The artists who contributed their work to this book represent those branches. They represent a wide variety of styles from pop to cute to exotic, and they employ some of the most cutting-edge techniques. Yet they are all clearly rooted in the traditional style of Japanese illustration.

GALLERY

Yu Kagei.

Kagei Yu imbues her elegant characters with a soft, realistic look that is unusual in the world of computer graphics illustration.

Yu Kagei draws entirely on the computer for efficiency and reliability. She uses a maximum of three layers and minimizes the amount of time spent working at high resolution. Her technique is especially suitable for working on unstable platform environments such as Mac OSX or on customized Windows platforms.

影井 由宇

Yu Kagei

Year of birth : 1973
Place of birth : Yamaguchi
Graduate school : Tama Art University
Gender : Female
Works appeared in : Ha-Shinchoki (cover illustration for a history novel)

Working Tools
Main Computer : self-assembled
OS : Windows 2000
Memory : 512MB
Clock waves : 666MHz
HDD : 40GB
Applications : Adobe Photoshop, Corel Painter
Accessories : WACOM Tablet
Video card (win) : GeForce2 MX

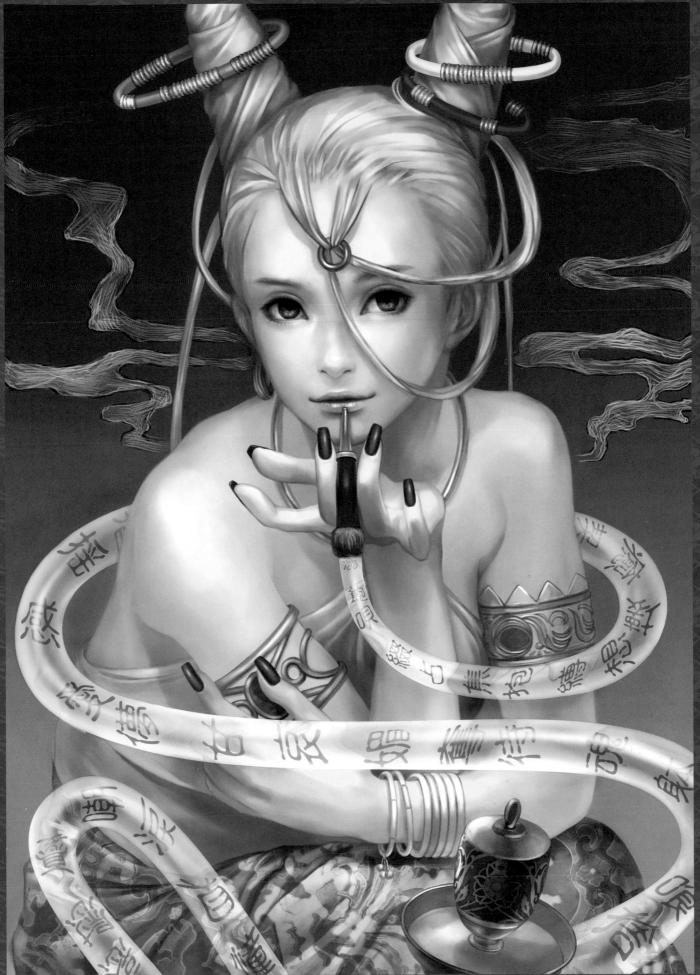

PIPE

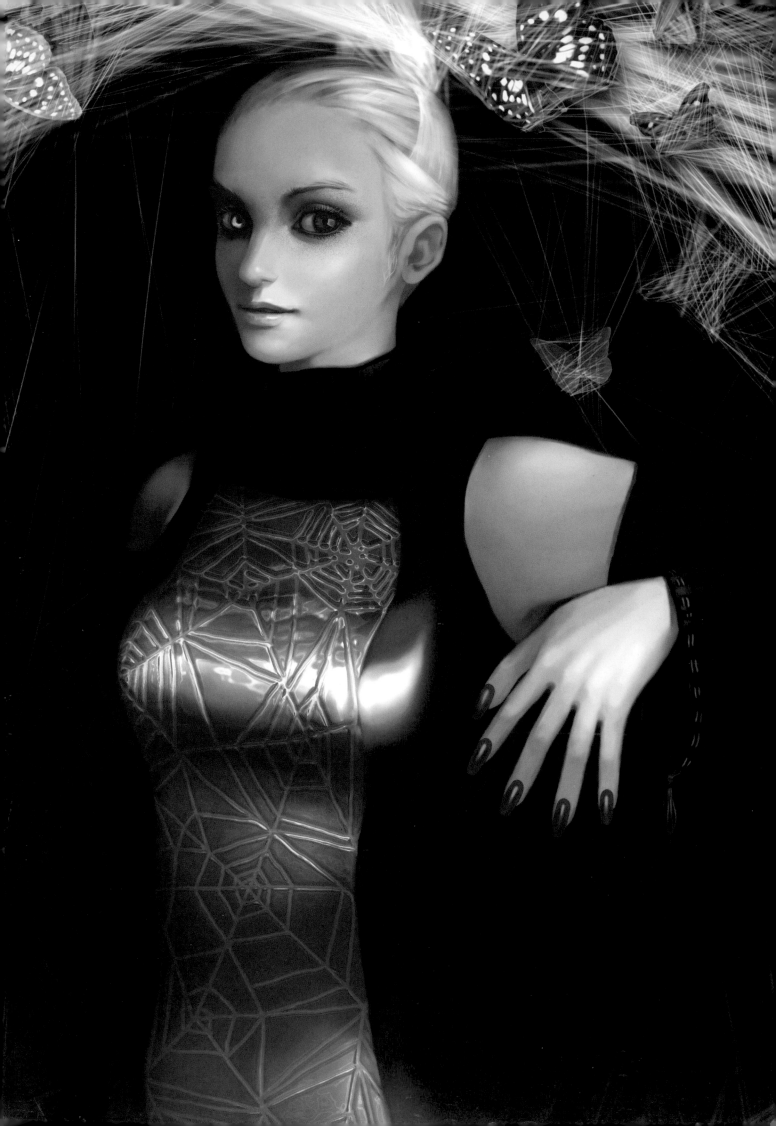

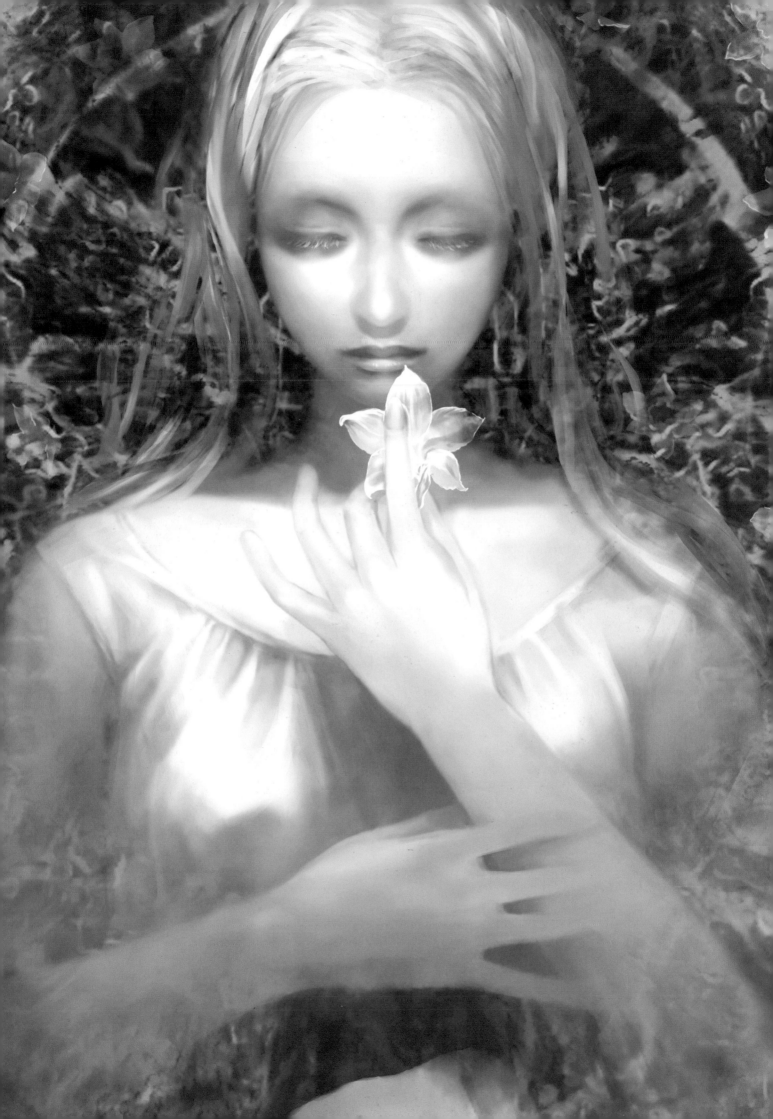

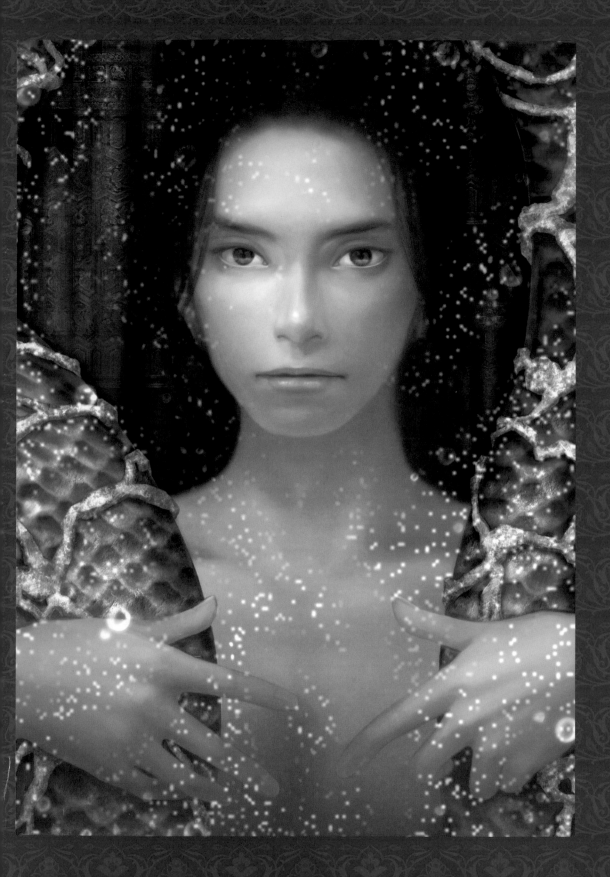

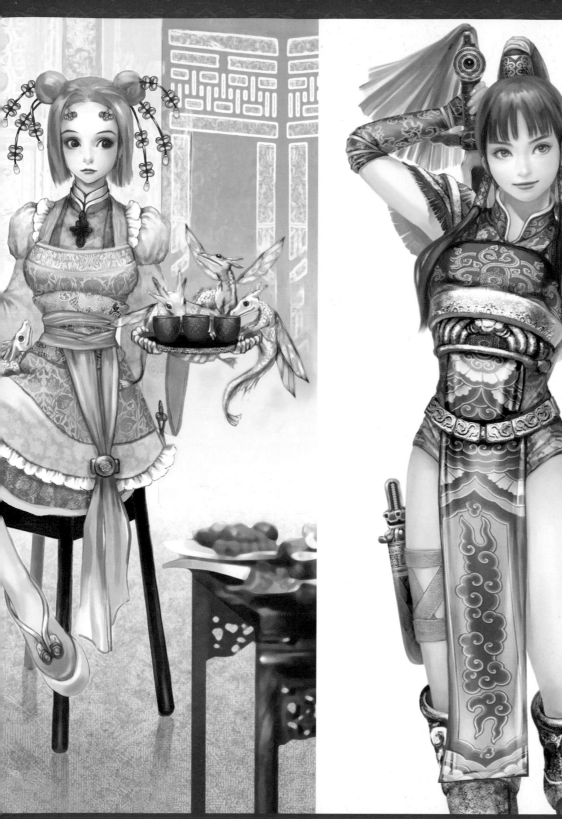

STEP BY STEP

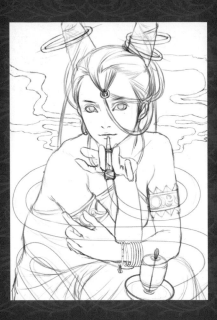

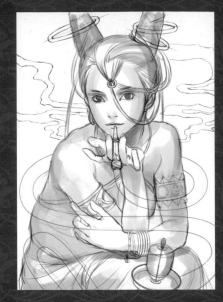

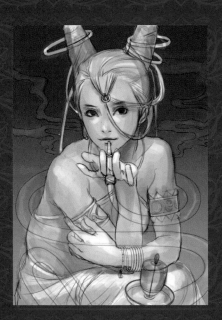

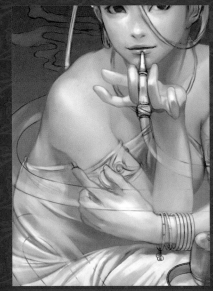

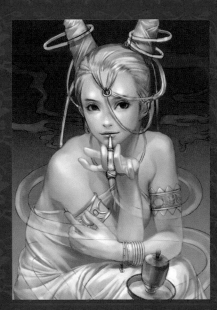

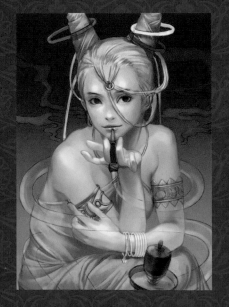

1. First I make a rough sketch.

2. I determine which direction the light is coming from in the picture, and then work out an overall distribution for shadows.

3. I increase the resolution and continue adding detail to the sketch, based on picture composition and textural effects desired. I use the Brush Tool and varied pressure to express gradation.

4. At this stage, I set the image mode to Grayscale. As the picture comes into focus, I draw in some texture.

5. I switch to RGB by selecting Image -> Mode -> RGB. Then I convert the image to Sepia by selecting Image -> Adjustments -> Hue/Saturation.

6. Now I am ready to add color. I make a separate layer and try out various colors with Layer Option set to Hard Light.

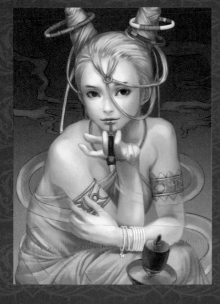

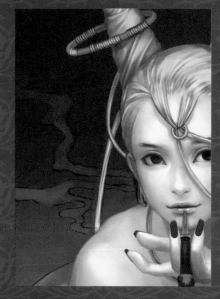

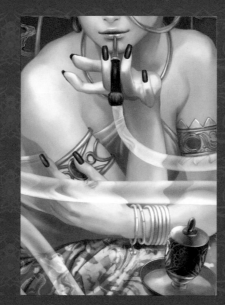

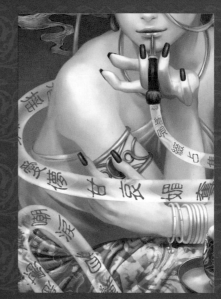

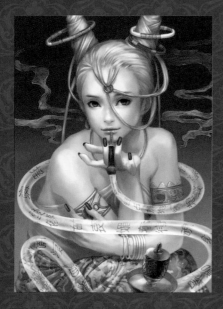

7	8	9
10	11	12
13		

7. I increase the resolution to 350 dpi and make small adjustments to the entire picture.

8. I draw two patterns for the character's clothing (see the two images at right,) and add them as a separate layer to the picture with Layer Option set at Overlay.

9. I fill in the background with the Gradient Tool. To add color, I temporarily divide the gradation into layers, and set the layer mode in Gradient Editor to Color.

10. I select the glass tube picture element and add Alpha Channel 1, Filter -> Distort -> Ripple.

11. I draw in more textural detail.

12. I type Japanese kanji with Layer -> Type -> Rasterize Layer. I add the Distort filter to the type layer by selecting Filter -> Distort -> Ripple. I also use Edit -> Distort -> Rotate and Enlarge/Shrink to get the effects I want when I place the letters on the glass tubing.

13. I add highlights to the glass tube and make fine adjustments to complete the work.

Hirofumi Fujiko

藤子 浩史

Fujiko's uncomplicated style of character drawing infused with energy and lighthearted nonchalance demonstrates outstanding artistic ability.

Hirofumi Fujiko employs techniques that are efficient and emphasize speed.

Colors for the basic outline and for a significant portion of the illustrations are applied using Copic Markers, and then watercolor pencils are used to add supplementary tones and details.

These techniques are becoming very common for non-digital Manga artists and illustrators because they take less time than creating traditional watercolor pictures using color inks and poster colors.

Hirofumi Fujiko

Place of birth : Chiba

Gender : Female

Working Tools

Markers, colored pencils, manga paper

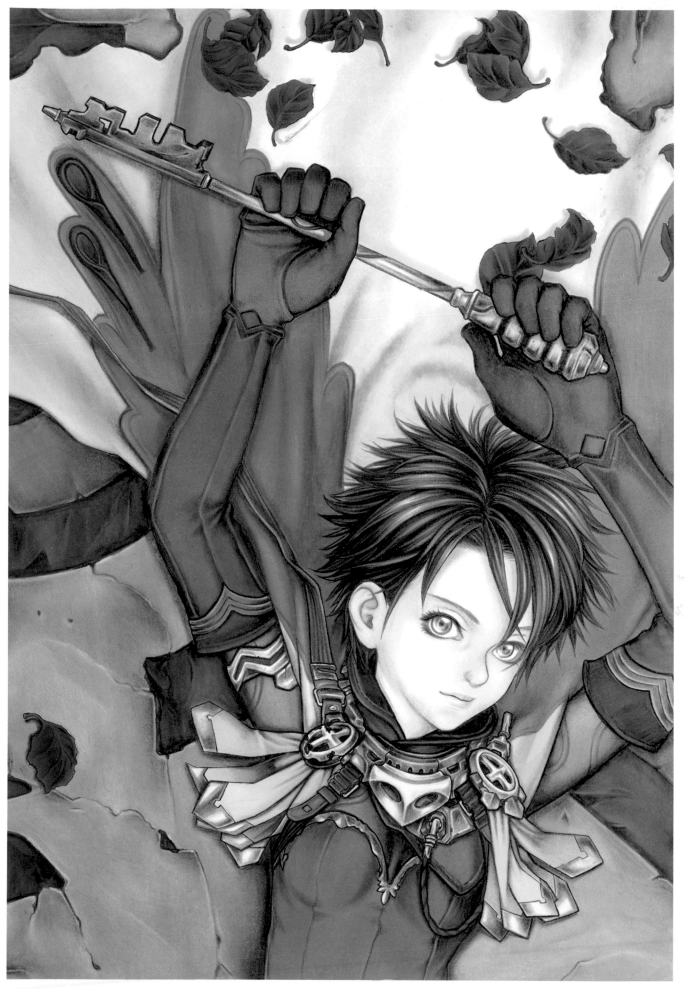

Untitled

Untitled

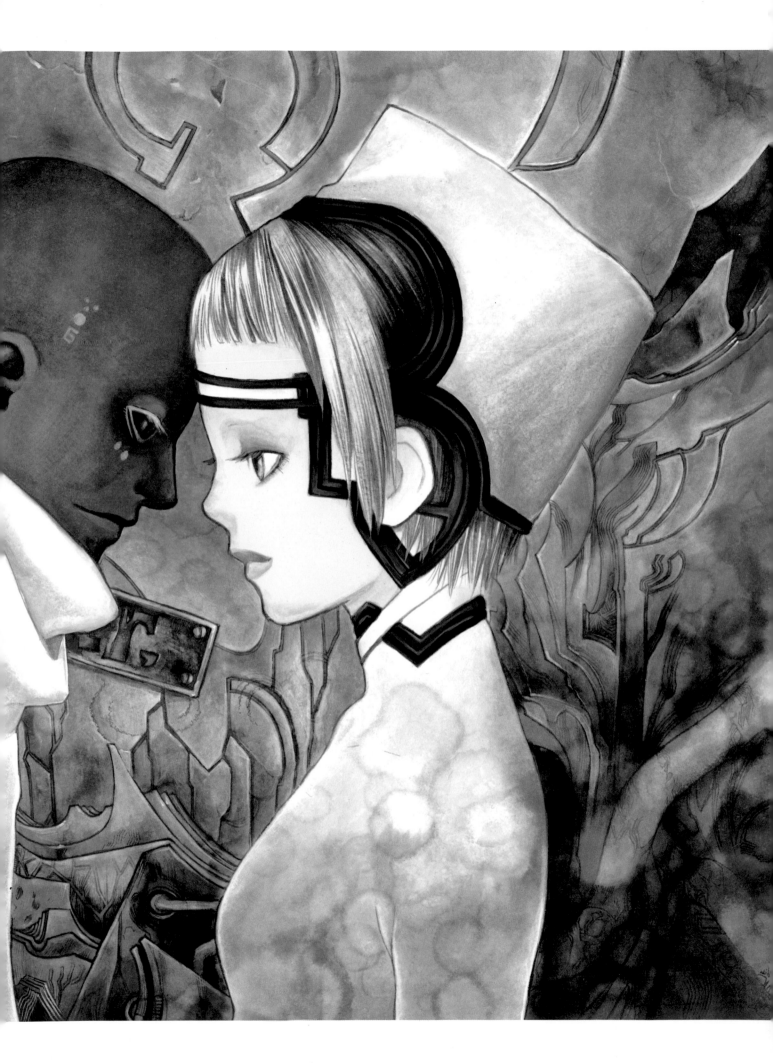

1. Digital Comickers
2. Bloom Planet
3. Untitled
4. Embryo 1 Enigma

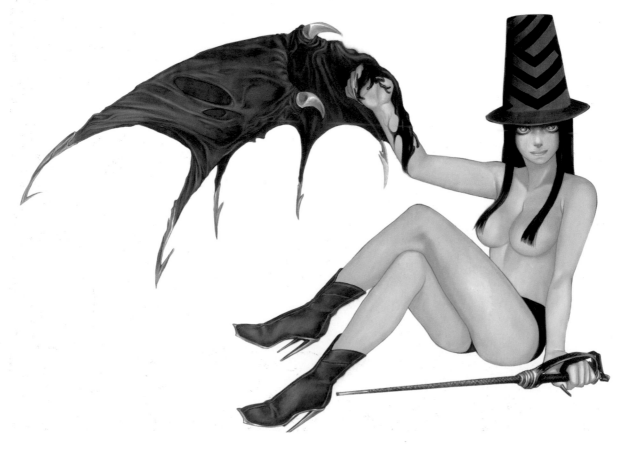

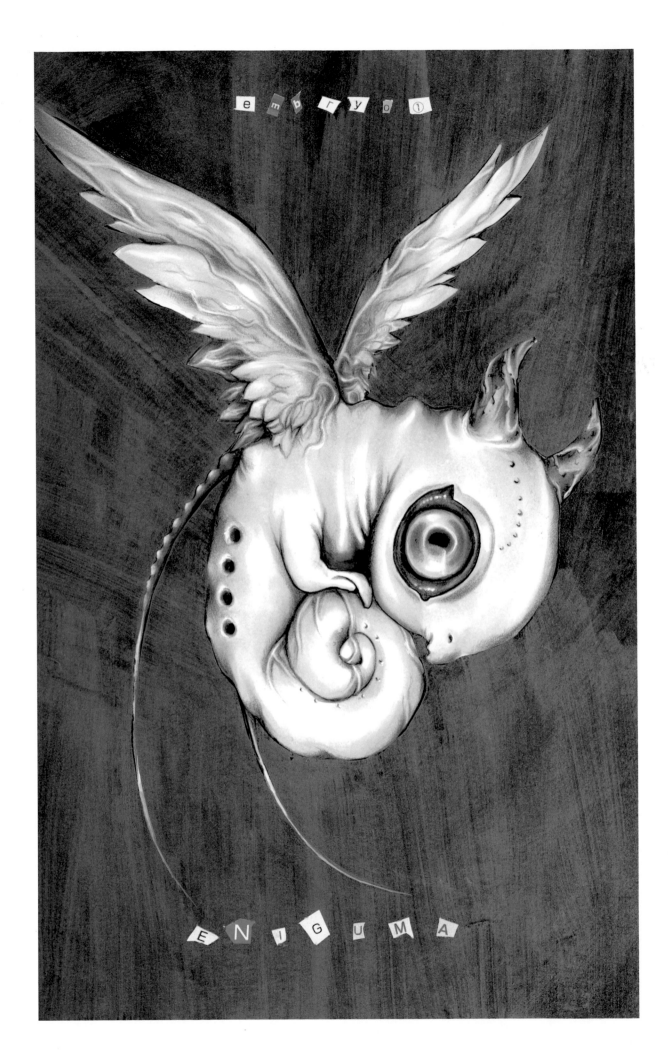

STEP BY STEP

1 First I create the outline drawing with pencils.

2 Then I trace the outline with red-brown watercolor pencil.

3 Note that with this technique, not all the lines are traced with watercolor pencils. A brown ballpoint pen is used to add more lines on the drawing.

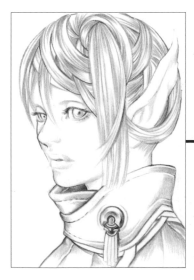

4 I erase the pencil outline using a rubber eraser and apply rough colors with watercolor pencils. This completes the preparation stage.

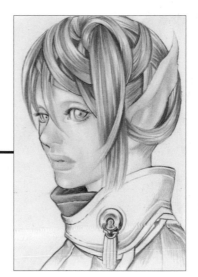

5

Now I apply color to the hair and skin with Copic Marker, except in the highlight areas.

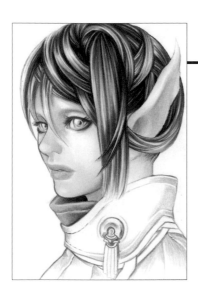

6

Copic Markers are best suited for base colors, so do not overuse them in your drawing.

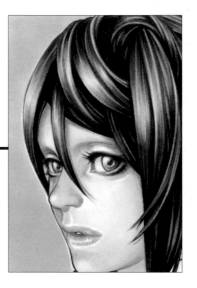

7

Layer the colors with watercolor pencils on top of the Copic Marker area to let colors come out more. Details of the eyes and hair colors are added with watercolor pencils.

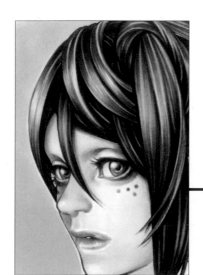

8

Completion.

Nanamirio

Nanamirio is a highly unusual artist, expert at the special technique she has devised of trickling ink to achieve the effect of soft light.

One may think that Nanamirio works in colored ink or watercolor. On the contrary, all of her illustrations are done with Copic and its refilling inks. Copic is not an easy tool to handle. While the colors are well preserved when they are dry, they cannot be gradated or mixed in the standard way. Nanamirio invented a very unique method to solve this problem by using Colorless Blender, the exclusive liquid thinner for Copic marker.

ななみ りお

Nanamirio

Year of Birth : 1980
Place of Birth : Yokohama, Kanagawa
Graduate School : Student at Tama University of Art
Gender : Female
Works appeared in : Comickers 2001 Summer issue

Working Tools
Copic, Mili-pen, Canson

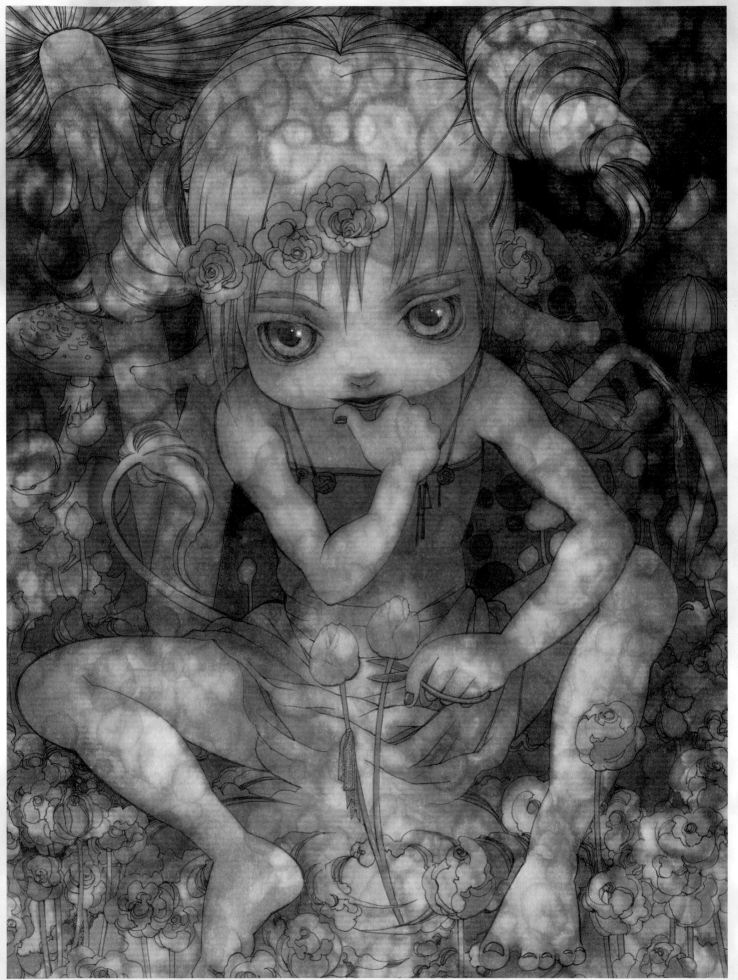

A Girl With Mischievous Expression

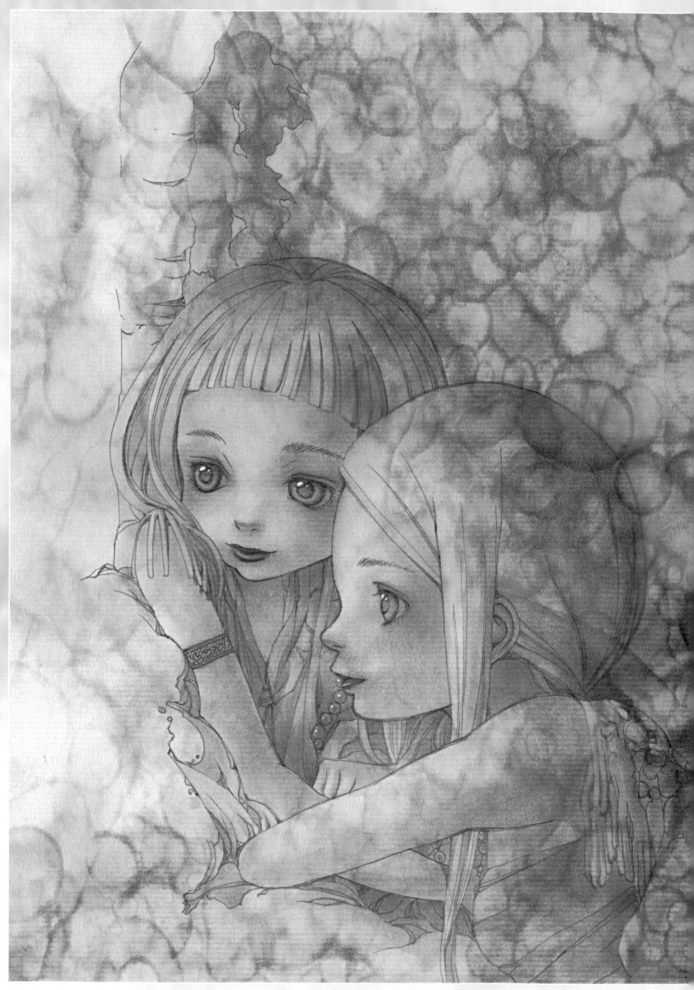

Bond

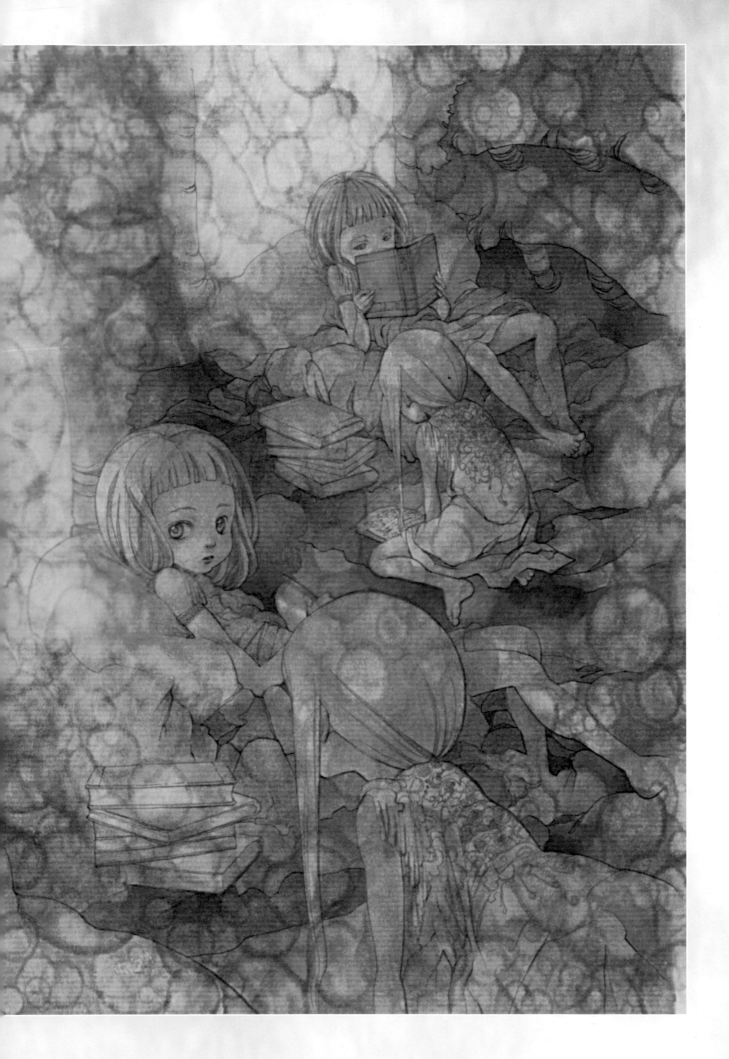

STEP BY STEP

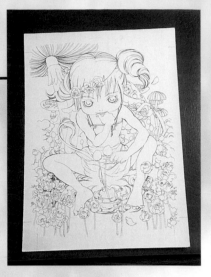

1

I draw a fairly detailed first sketch on Muse Cotton drawing paper using a standard drawing pen such as HI-TEC-C brown. I then blend it to make it appear purplish.

2

I apply Copic Y31 in my favorite colors, mid-tone tints, using rapid brush-strokes to achieve the brush mark effect I want.

3

At this stage I drip Colorless Blender, the liquid thinner, directly from the bottle onto the drawing. The liquid blurs the colors and drawn lines. I then apply the liquid with a brush to enhance the blurred effect.

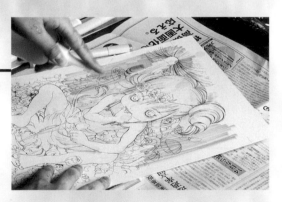

4

I drip color ink directly from Various Ink, the Copic's refill bottle, onto the drawing. This creates an interesting stain effect which is unique to my illustrations.

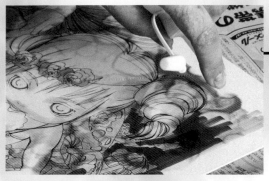

 5

I apply B97 dark blue to parts of the drawing and stain using Colorless Blender. The combination of the stained dark and natural colors adds dimension to the drawing. I combine yellow and purple to create a deep brown color that I then add to the illustration. I apply darker tones of the same colors to create shadowy areas and to give the illustration depth.

6

I continue to drip colors and liquid thinner, and enhance the stained effect with a #0 Colorless Blender brush. The illustration is finished when no white areas remain.

7

The illustration at right shows my drawing after thirty minutes of work. It is still far from completion. Copic is a challenging art material since the number of colors are limited. However it allows me to create my signature style of stained patterns that would not be possible using watercolors. I began using Copic after I saw how pencil lead powders are blended with benzine in art school. I decided this method could be applied to other art material and after much experimentation found the best effect with Copic.

Noriko Meguro

Noriko Meguro adds a cyber touch to her unique vision of translucent worlds.

The great appeal of the digital images by Noriko Meguro is their "analog" brushwork appearance, which she achieves by drawing all of the elements by hand.

It is interesting to note, in the step-by-step example following, to what extent and at which stages she draws by hand.

The rough layout focuses more on the complete silhouette and color tone than on fine details. Yet the final drawing gives the impression that the artist already had a clear conception of the finished product in the initial stages.

Noriko Meguro

http://www.a-circuit.com/

e-mail : serene@a-circuit.com

Place of birth : Tokyo

Final graduate school : Gakushuin University

Gender : Female

Representative works : cover and editorial illustrations of the Japanese editions for

"Yatsuzaki Jack (Jack the Ripper)" (by Hideyuki Kikuchi, published by Shodensha Bunko),

"Hitokiri Kimon" #1/#2 (by Atsushi Kano, published by Gakken M Bunko),

"Rhodes Island RPG series" (by Steve Jackson, published by Kadokawa Sneaker G Bunko), and many others

Working Tools

Main Computer : Power Macintosh G4

OS : Mac OS 9.2

Memory : 1GB

Clock Waves : 800Mhz

HDD : 100GB

Applications : Adobe Photoshop, Painter, SHADE PRO R2

Accessories : Tablet/WACOM intuos i-900, Scanner/EPSON GT-8700

目黒 詔子

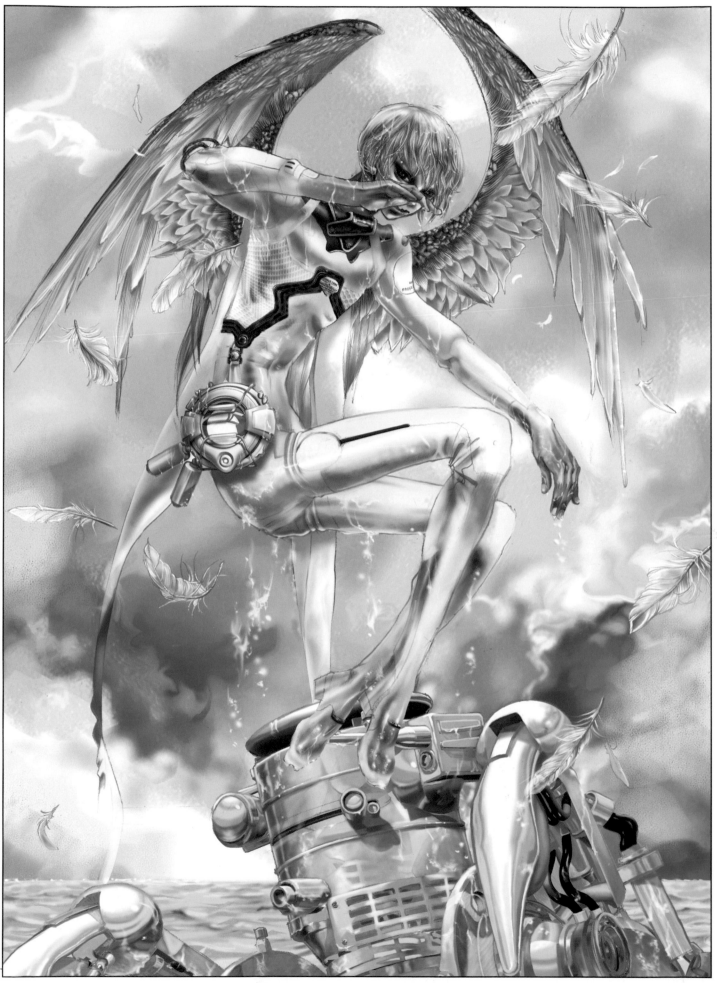

Untitled

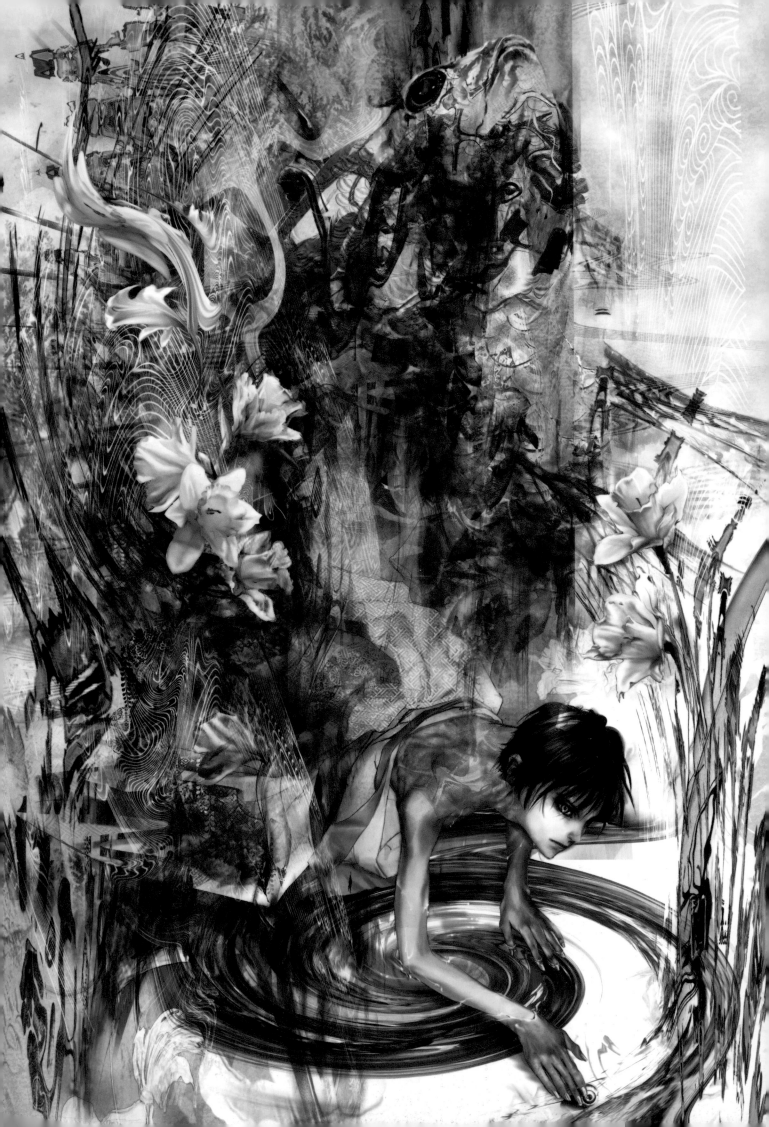

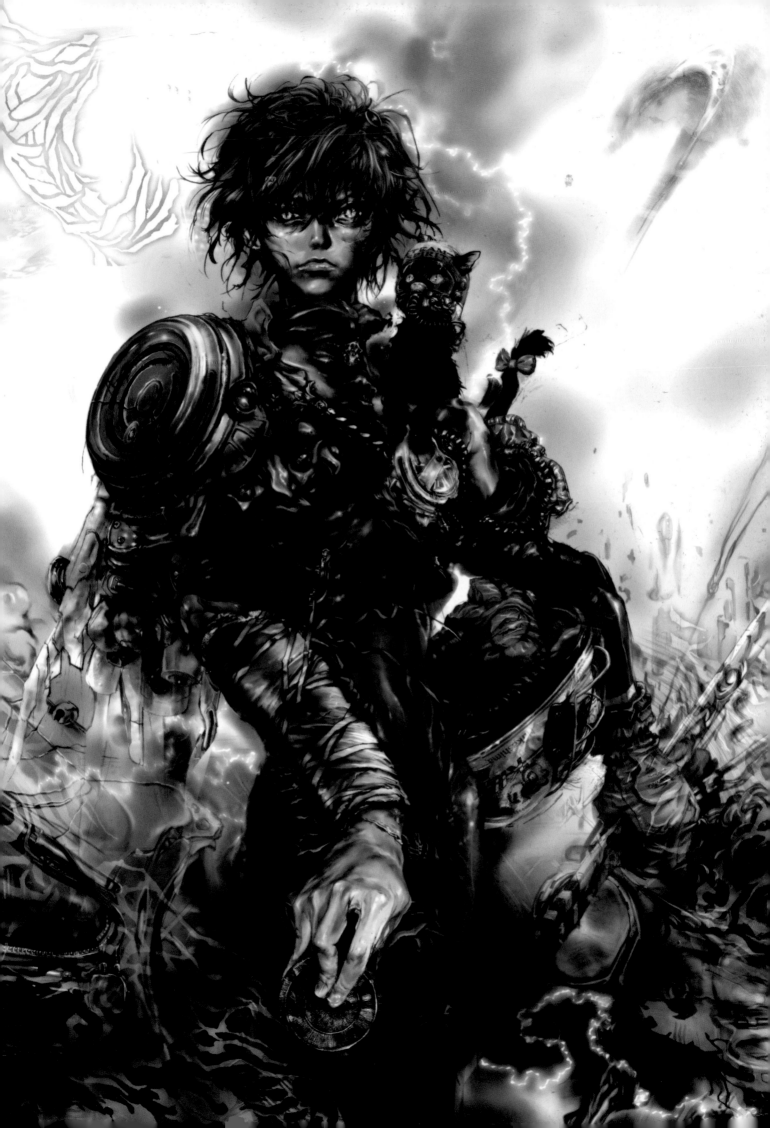

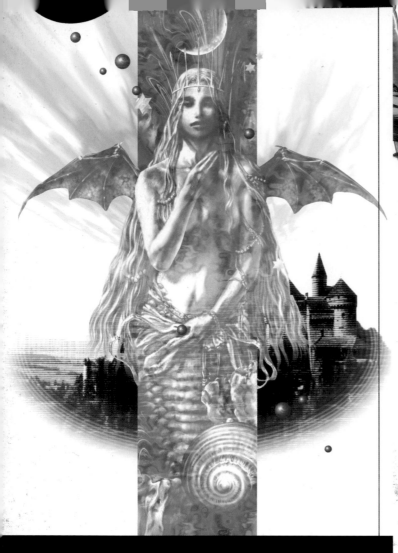

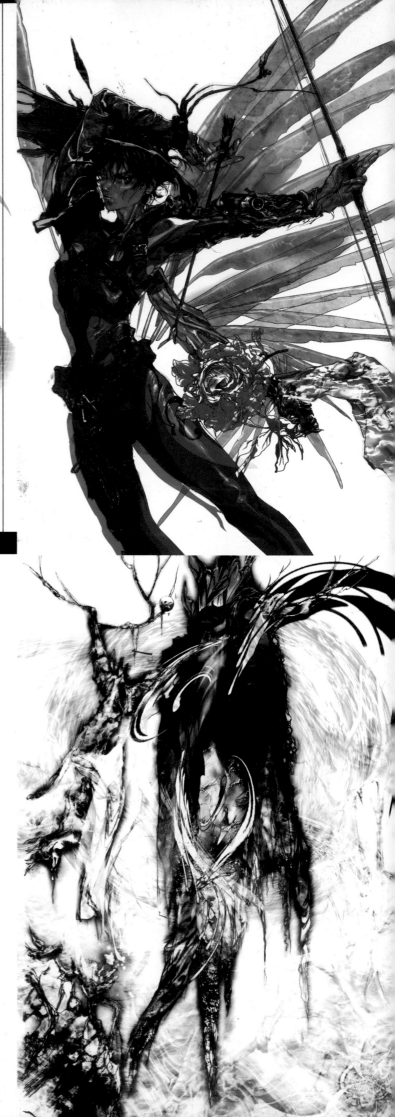

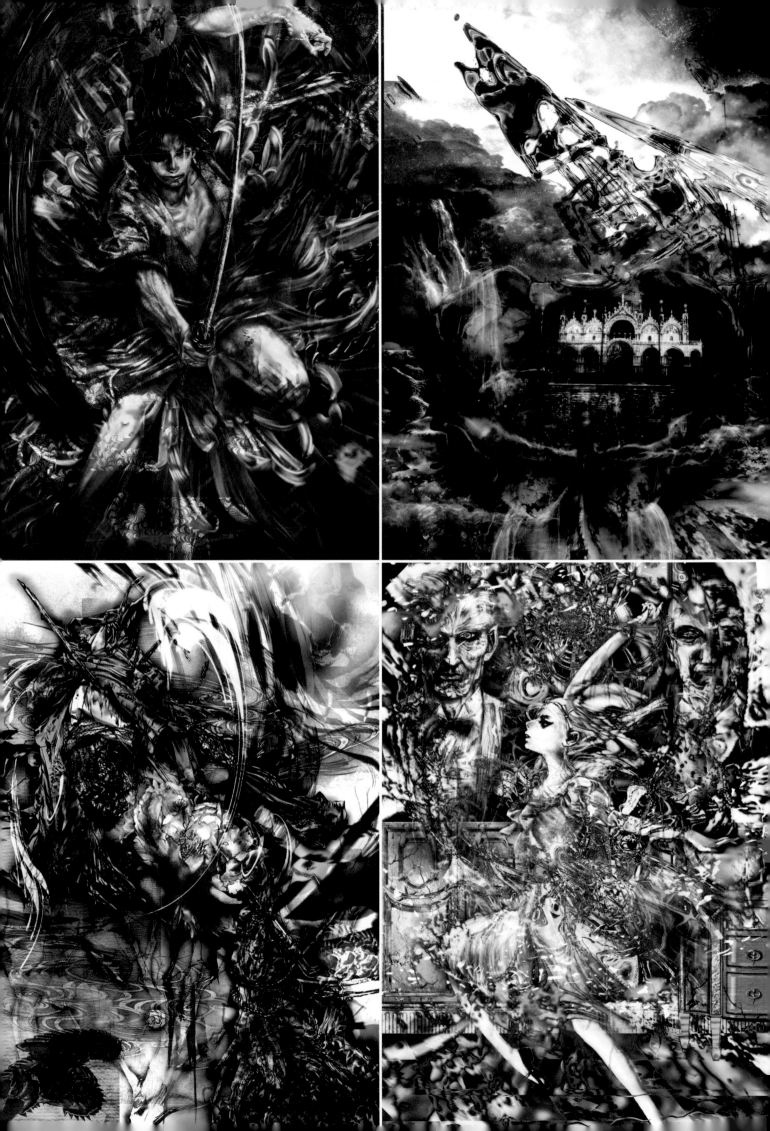

STEP BY STEP

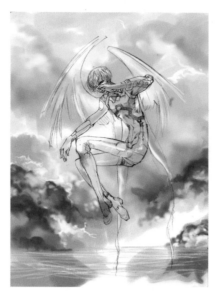

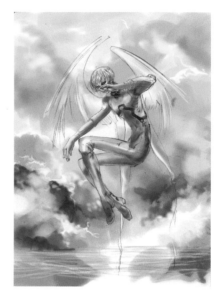

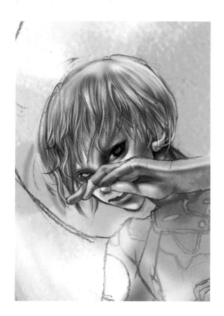

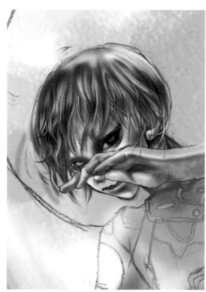

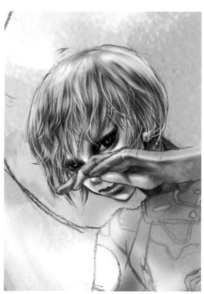

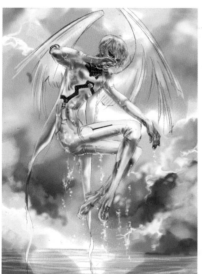

1. I start by making a pencil sketch of the character. I scan in the sketch and use alpha channel to remove the white space from the drawing, leaving just the outline. I color the lines in sepia shades. At this stage, I also make the masks for the collar and the decoration on the costume.

2. I create a rough shadowing of the entire body while blending the colors so that the character melds with the background. In order to achieve uniform coloring, I paint the top layer orange and cover it with soft light.

3. For the facial shadowing, I apply several layers of a dark shade and spread them out on the face and hair, then add a bright shade on top. The eyes in the sketch were too thin, so I widen them.

4. I apply a dark shade to the hair in stage 3. To get a natural look, I create a basic shadowing first and work gradually into detail shadowing.

5. I emphasize the shadow around the eyes and add highlights to the eye periphery and the mouth. Starting in stage 4, I gradually lighten the hair until it takes on the natural look shown here. The character has just risen out of the water, so I draw in small water droplights to highlight the hair and make it sparkle.

6. Next, I add detail over the shadowing. I give the character a futuristic look by making the body appear translucent. I give a plastic texture to the collar and costume decoration. I also draw in water droplets dripping off the body.

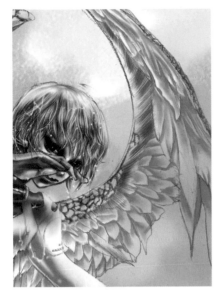

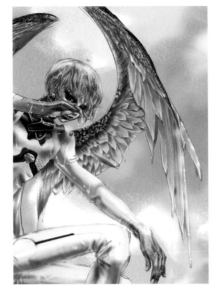

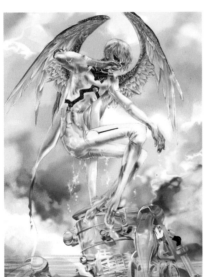

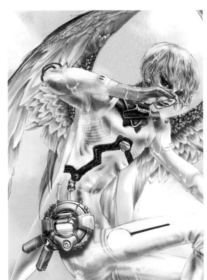

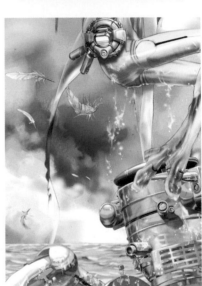

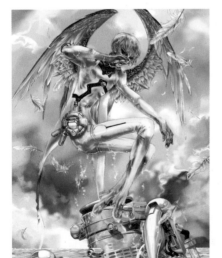

7. For the wings, I lock the line drawing against the background and apply several layers of thin color. I use this method, which is the reverse of how I color the face and hair, because I want to draw attention to the face and make the wings look transparent. I use a separate layer to draw a white reflection on the edges of the wings.

8. To complete the wings, I draw dark edges for contrast.

9. I create mechanical gadgetry using 3-D software and insert it into the picture. If the 3-D images are transported directly into a hand-drawn picture, they don't blend in properly, so I scan in the sketches and draw them by hand. I find 3-D software very convenient for producing images and sketches of imaginary objects.

10. Just as I did for the character, I scan pencil sketches of the mechanical objects into the computer, lock them against the background, and color them to blend with the background. I get rid of sketch lines and draw in the objects.

11. At this stage, the character is complete. My hope is that the soft blending of color on the edges dividing light and shadow areas gives the viewer the impression of a watercolor painting. The same goes for the mechanical gadget on the character's hip. I gave it the look of a material other than metal.

12. I add a sense of movement to the image by scattering some feathers in the picture. I complete the picture by adding touches of the purple in the sky to the sea.

13. After that, I merge the layers and correct spots in the image.

Shunpei.

春平

*Shunpei's illustrations display
an element of unique design and
a superior eye for composition
and color.*

The main characteristic of Shunpei's method of drawing is color shading. Her unique style of shading is achieved by color blotting. Although watercolors do not blot well, she chooses to use them as her main medium because she feels the overall effect of watercolors allows her to be more expressive.

Shunpei
ameotho@fsinet.or.jp

Year of birth : 1977
Place of birth : Nagasaki
Gender : Female
Works appeared in : Comickers up to the 2001 Spring issue ("Crome Black Mode"),
Comickers Manga Collection " error, " step-by-step illustration for Tarlens Eco Line

Working Tools
Tarlens Eco Line (color ink)
Holbein transparent watercolors
Dr. Martin's color ink
Acrylic gouache
Watson paper

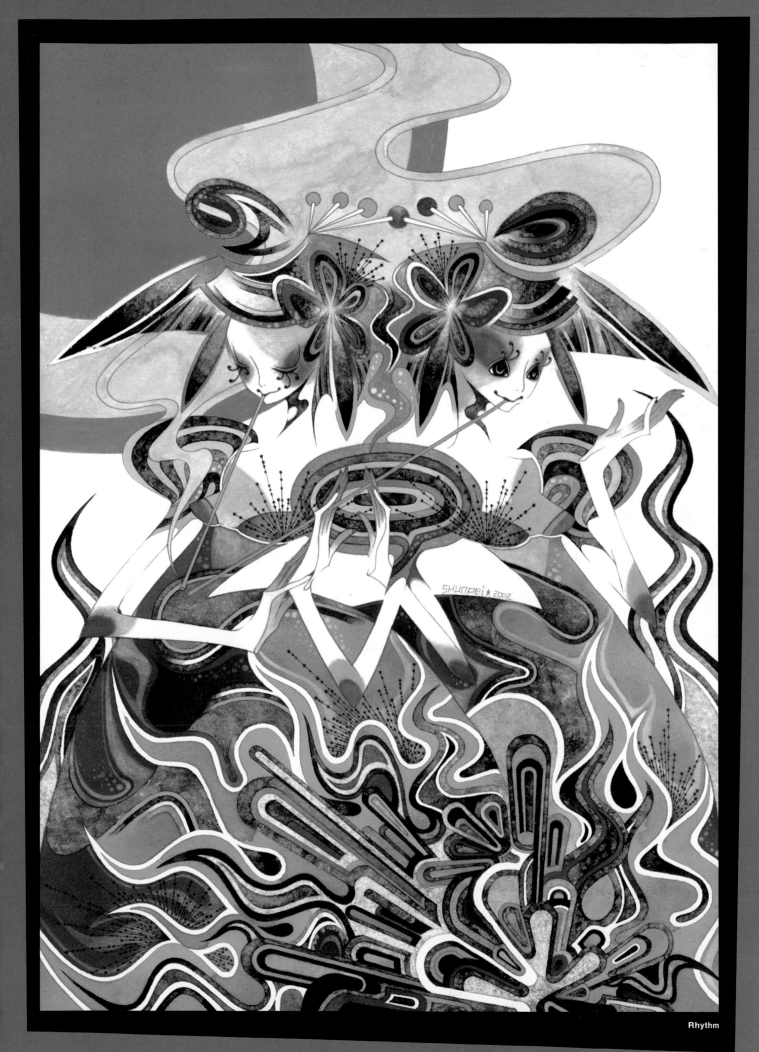

Rhythm

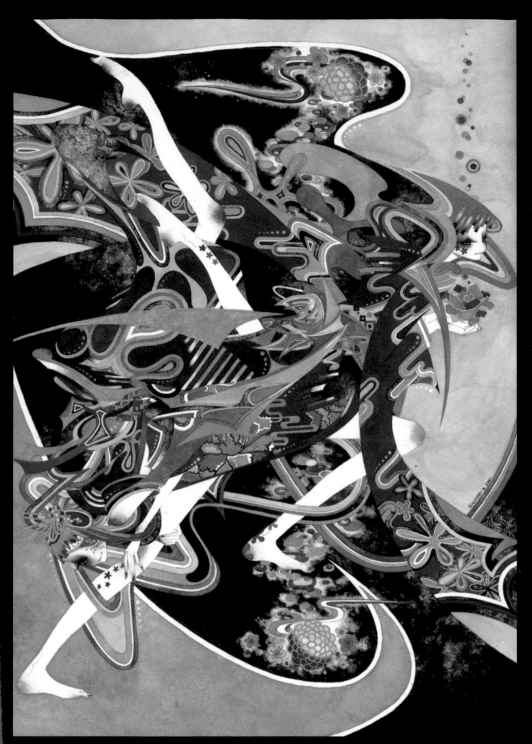

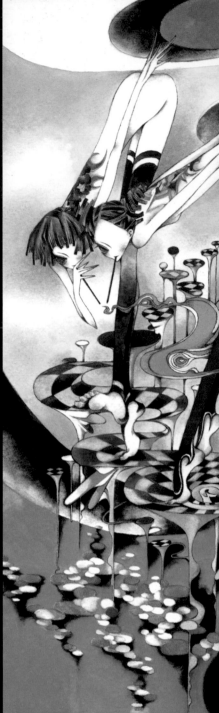

1. Pondered
2. Shangri-la
3. Echo

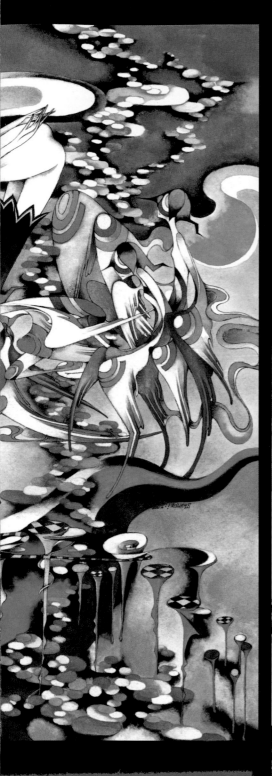

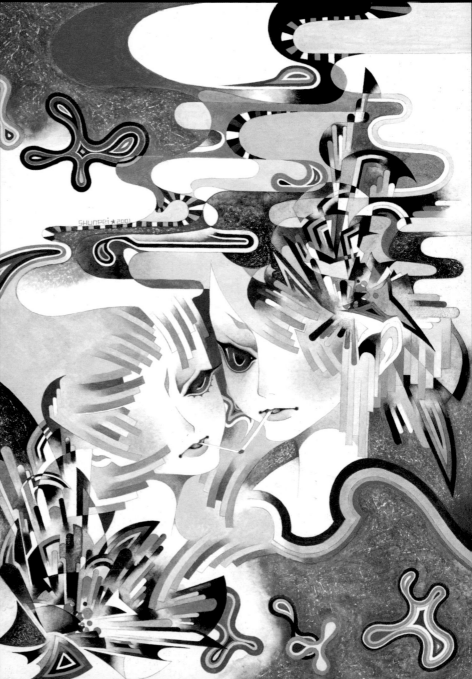

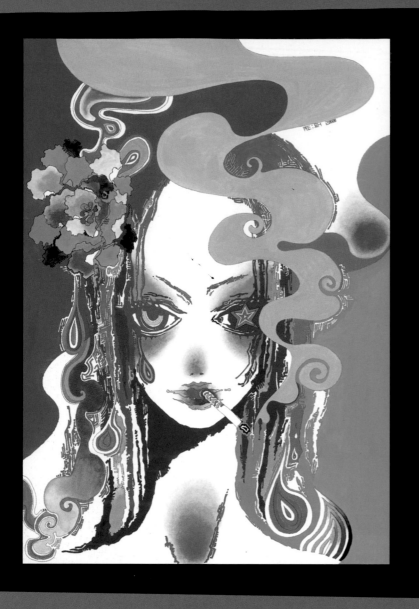

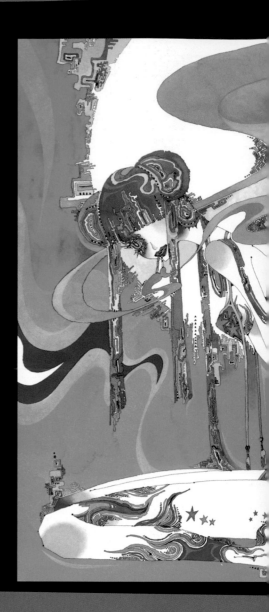

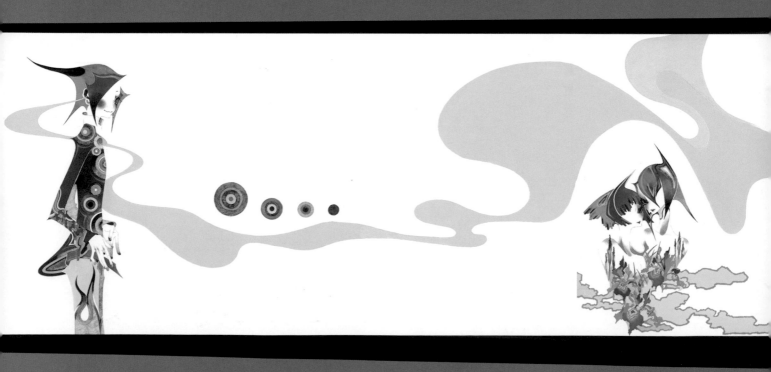

4. Jishin
5. Candy
6. Shunpei

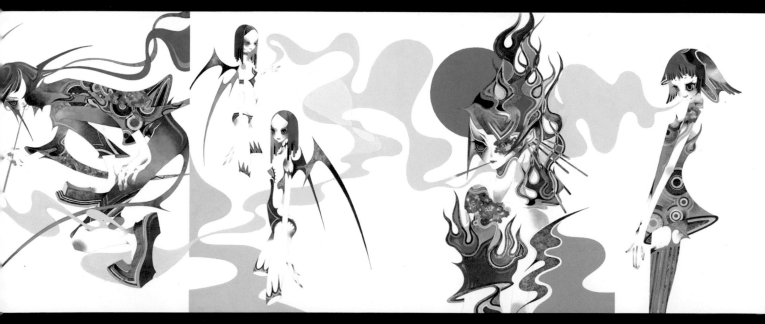

STEP BY STEP

1 I draw a rough sketch.

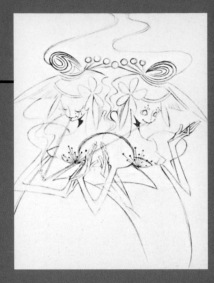

2 I create the outline of the sketch on watercolor paper - usually Watson paper - and start blotting colors onto it.

3 I blot the color inks with a brush and do not mix the blots together.

4 It is at this stage that I begin blending the colors along the borders of the sketch outline with water and thinner tones. The effect is one of color shading. I replicate this pattern onto the entire surface of the artwork so that it becomes the overall texture for the background.

5

I use an extremely fine brush, called Menso-Fude, to apply color in the very detailed areas of the artwork.

6

When applying colors with this brush, it is important to make multiple layers with pale colors. This creates a very rich effect.

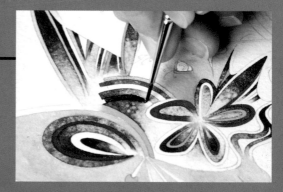

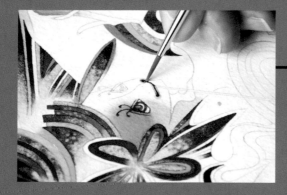

7

I blur the image area with water and create the effect of color shading by spotting water on the designated area.

8

For the parts of the artwork I want to accentuate, such as the eyes and eyelashes, I use black watercolor pencils. This helps the outline stand out.

Hinoki Amamori

天森檜

Amamori uses markers to create "down-to-earth" fantasy worlds.

Amamori works almost exclusively with Copic brand alcoholic markers. While Copic manufactures an extremely rich variety of colors, Amamori sometimes opts to custom mix his own new colors. To do this, he mixes existing Copic inks to create entirely new colors, and then puts the freshly-made colors into empty refill containers. He also uses a tool called Copic Airbrush, a simplified airbrush tool manufactured by Copic to be compatible with their markers. As an artist, Hinoki Amamori gets the most out of the medium of markers.

Hinoki Amamori

Year of birth : 1974
Place of birth : Osaka
Graduate school : Osaka Art University (Design major)
Gender : Male
Works appeared in : Comickers

Working Tools
for digital illustrations
Main Computer : SONY VAIO PCV-R62
OS : Windows 98
Memory : 128
Clock Waves : 600
HDD : 20GB
Applications : Adobe Photoshop 6.0, Painter 6.0
Accessories : Tablet/WACOM Intuos, Scanner/CanoScan FB636U, Printer/EPSON PM-770C
Video Card : (win)

for non-digital illustrations
COPIC Marker (Block type), Various COPIC Inks , Polychromos colored pencil, Holbein Color Ink (white)
Drawing paper : Muse Kent board/Crescent board #99/#310

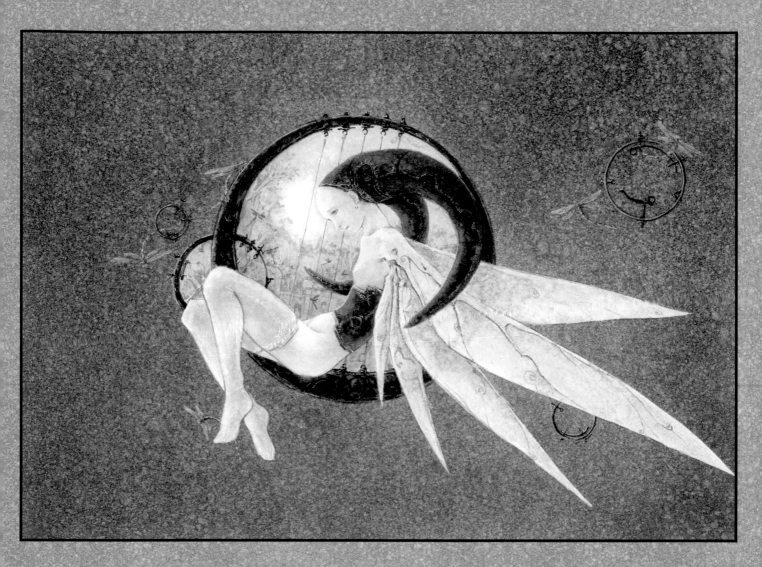

Untitled

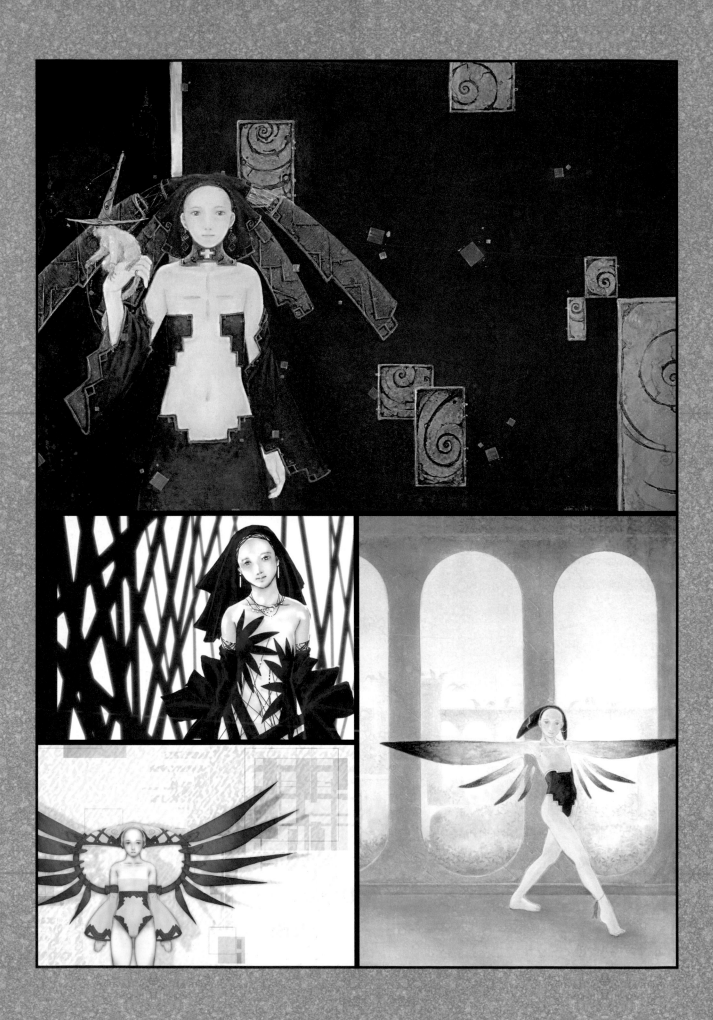

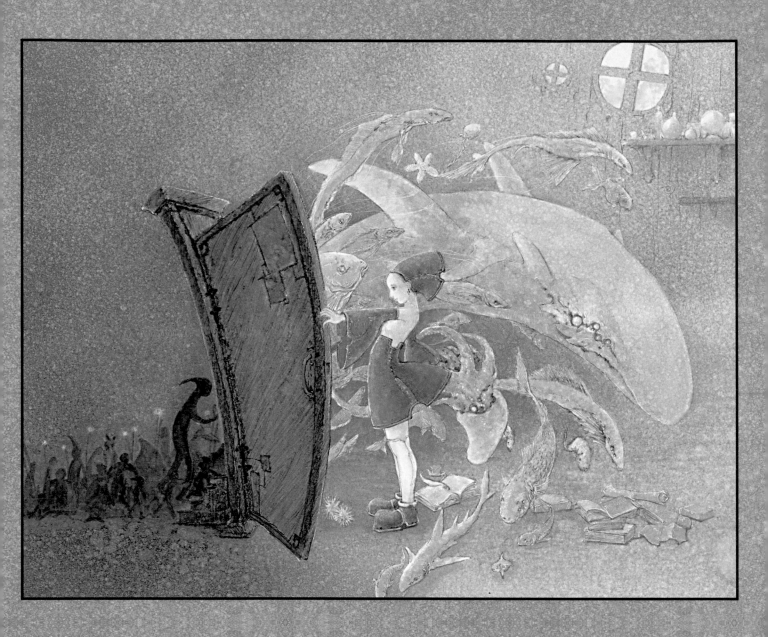

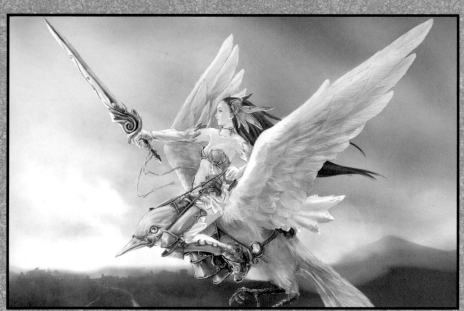

1. Liberation
2. Wallkur
3. Spiral Door
4. Pale Season
5. Awakening
6. Bird

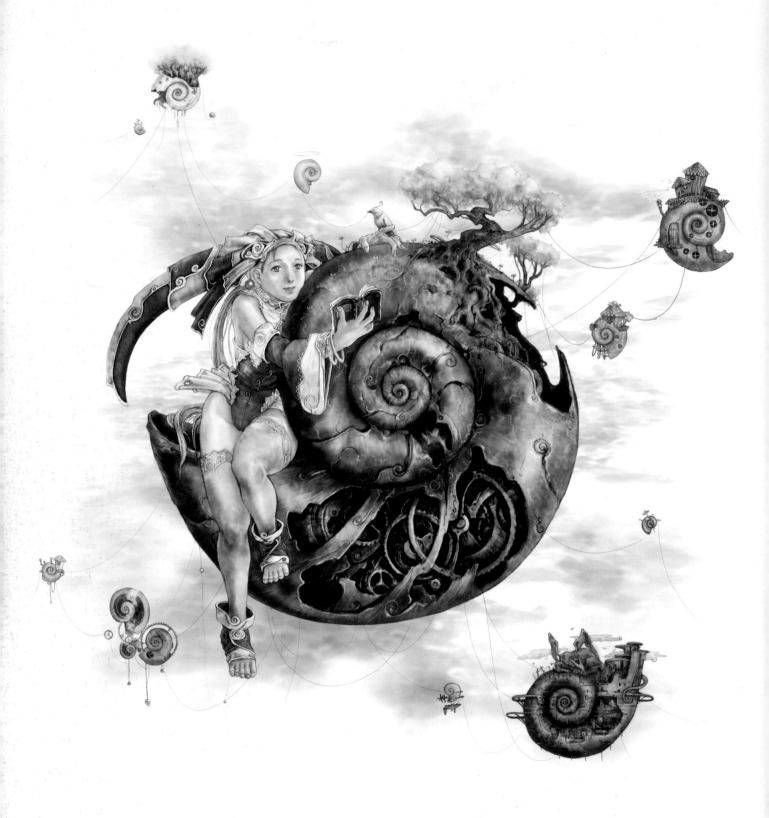

7. Spiral Nest
8. Spiral Fossils

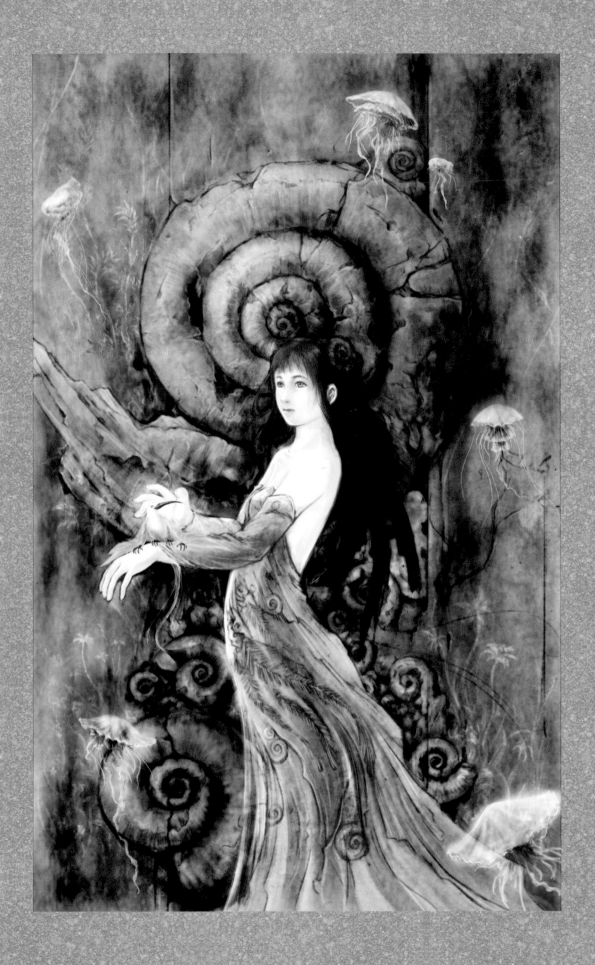

STEP BY STEP

1 After protecting the area where I have drawn an outline, I create the background colors using the Copic Airbrush.

2 Then I proceed to the area where the dark colors are to be applied, spray the colorless blender, and prepare for the light-colored parts.

3 When all of the colors are applied, the outline drawing from the base layer disappears.

4 Here, I re-apply color to the main parts of the outline drawing.

5

To define the shapes of each element, I apply colored pencil to the back side of the outline drawing and use this to trace the shape of each element.

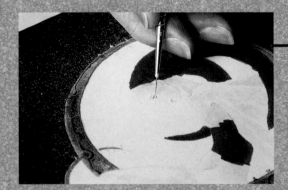

6

I then add more colors using a round pen or fine brush.

7

Completion.

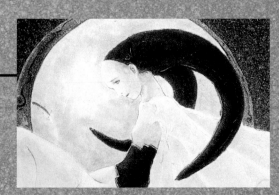

Sunaho Tobe

戸部淑

Sunaho Tobe's gently colored, nostalgic illustrations of likeable anime-type characters are beautifully and precisely rendered.

Producing an original drawing, scanning it into the computer, and then editing it is a standard technique.
As such, the quality of the finished picture depends to a large degree on the individual artist's skill level.
Notice the meticulous techniques Sunaho Tobe employs; these enable Tobe to achieve a high degree of precision in her finished work.

Sunaho Tobe

jh7a-sezk@asahi-net.or.jp

http://www.asahi-net.or.jp/~jh7a-sezk/

Place of birth : Fukuoka

Gender : Female

Representative work : "Levelle Fantasia (PS2) " character design

Working Tools

Main Computer : NEC VALUESTAR

OS : Windows 98 Me

Memory : 256MHz

HDD : 30GB

Applications : Adobe Photoshop5.5J

Accessories : Scanner/EPSON GT-7000, Tablet/WACOM Intuos600

Video card (win) : internal

Untitled

1. Zettai Shonen Project image illustration
2. Untitled

-ALICE'S KINGDOM-

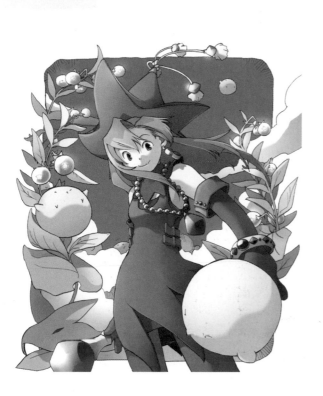

3. Colorful PURE GIRL
4. GAMESPOT
5. Illustration for homepage
6. Illustration for homepage

3	**4**	
	5	**6**

STEP BY STEP

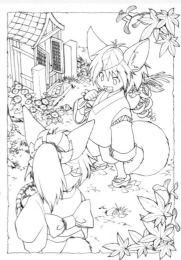

1 First, I do a rough sketch.

2 Next, I do a preliminary pencil drawing based on the sketch.

3 I place a separate sheet of paper over the drawing, trace the outlines, and scan the line drawing into the program. Then I remove the scanned artifacts and junk from the picture, make corrections, and adjust the picture size. Finally I make the line drawing into a layer in Adobe Photoshop.

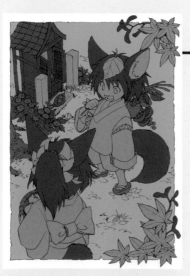

4 I cut the image resolution in half to color the picture. (This is a good method to use on computers with low processing power.) I use the Pencil Tool and Path Tool to color and make a separate layer for each of the picture elements. I turn off Anti-Alias for both tools during this process.

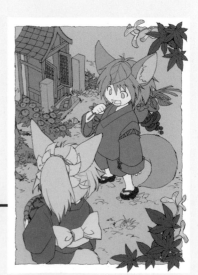

5 I select the Preserve Transparency box for the colored layers and then choose the colors I want to use for the picture. Once I have determined the colors, I fill in the color primarily with the Brush Tool and Path Tool.

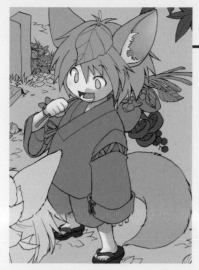

6

I fill in all the color this way. Depending on the picture element, I make separate layers for the shading and base color. It is convenient to select the Group with Previous option, because that enables the settings for the base color layer to be applied to the shading layer as well.

7

Next I put in highlights. Directly under the line drawing layer, I place a Screen layer with color where I want the highlights. I add an Overlay layer at 20% opacity to the entire picture in order to harmonize the colors.

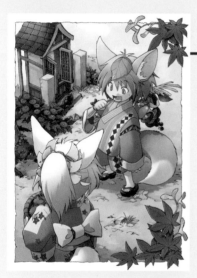

8

I merge and enlarge the colored layers, making adjustments to the details of the elements. This step isn't necessary if resolution is not halved, as I did in step 4.

9

I paste the picture into the original-size drawing file.

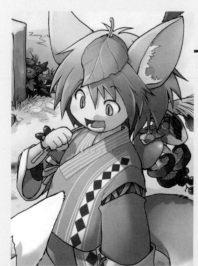

10

I change the color of the line drawing by selecting the Preserve Transparency box for the colored layers and then choosing the colors.

11

I make fine adjustments to the picture, adding a Normal layer over the line drawing layer in order to put highlights in the eyes. Finally, I merge the layers to complete the picture.

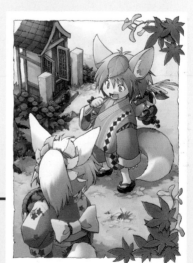

nini:

nini's dazzling, charming illustrations are done in a distinctive and popular style known as moe (after the name of a popular anime character).

At first, it may appear inefficient and complicated to make excessive use of the layer function, a technique that requires a high performance computer. However, modeling the various value settings can easily duplicate operations. This has become a standard method in the video game industry and animation studios. nini's use of a somewhat radical style of image processing is made possible by Photoshop's work efficiency and productivity.

nini

http://ak.sakura.ne.jp/~replica

http://webraiden.s9.xrea.com

delta_onlinehp@hotmail.com

Works appeared in : Colorful Pure Girl, Magique Premium, Mizuiro Anthology, F&C Tsukijan original illustration and others

Working Tools

Main computer : VAIO PCG-F50 (SONY)

OS : Windows 98

Memory : 256MB

HDD : 12GB

Applications : Adobe PhotoShop 6.0

Accessories : Scanner/CanoScan FB 636U, Tablet/WACOM Tablet,

External HD/I.O DATA HAD-i180G/US2 80GB

Video Memory : 2.5MB

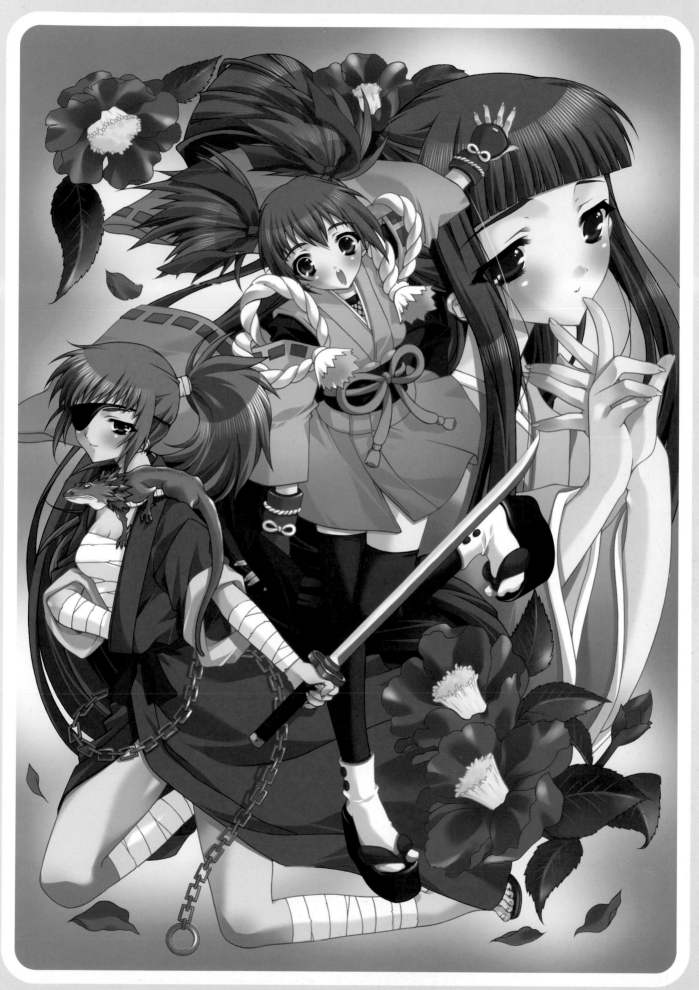

Untitled

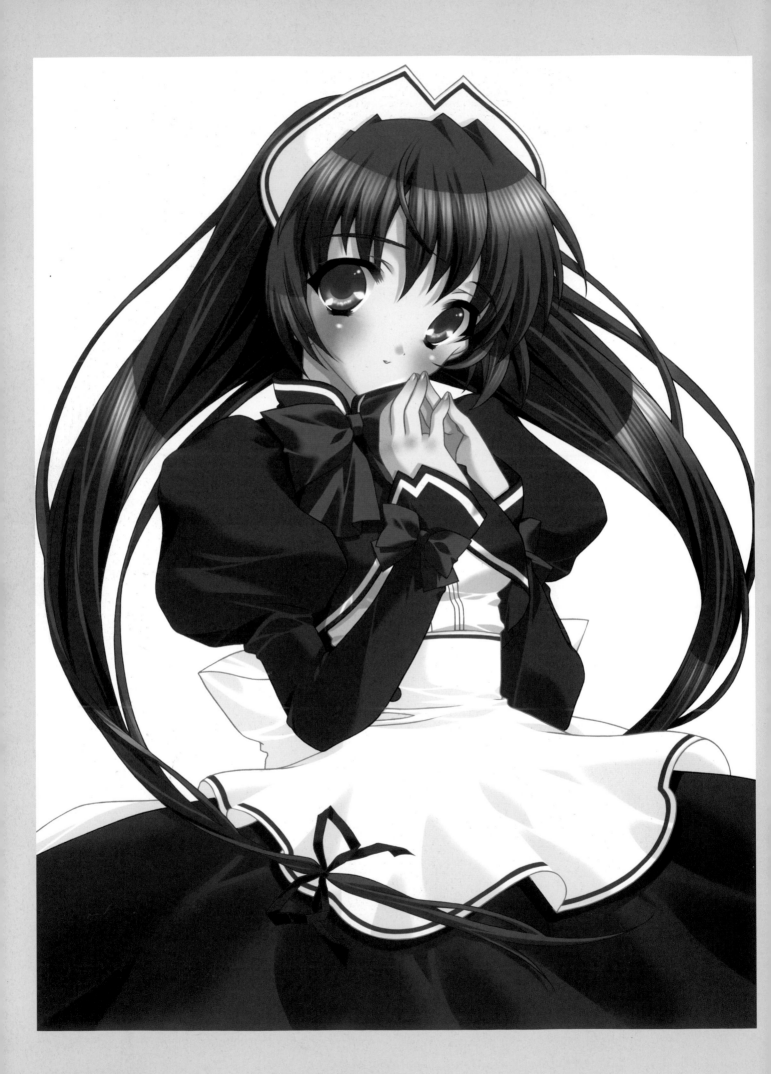

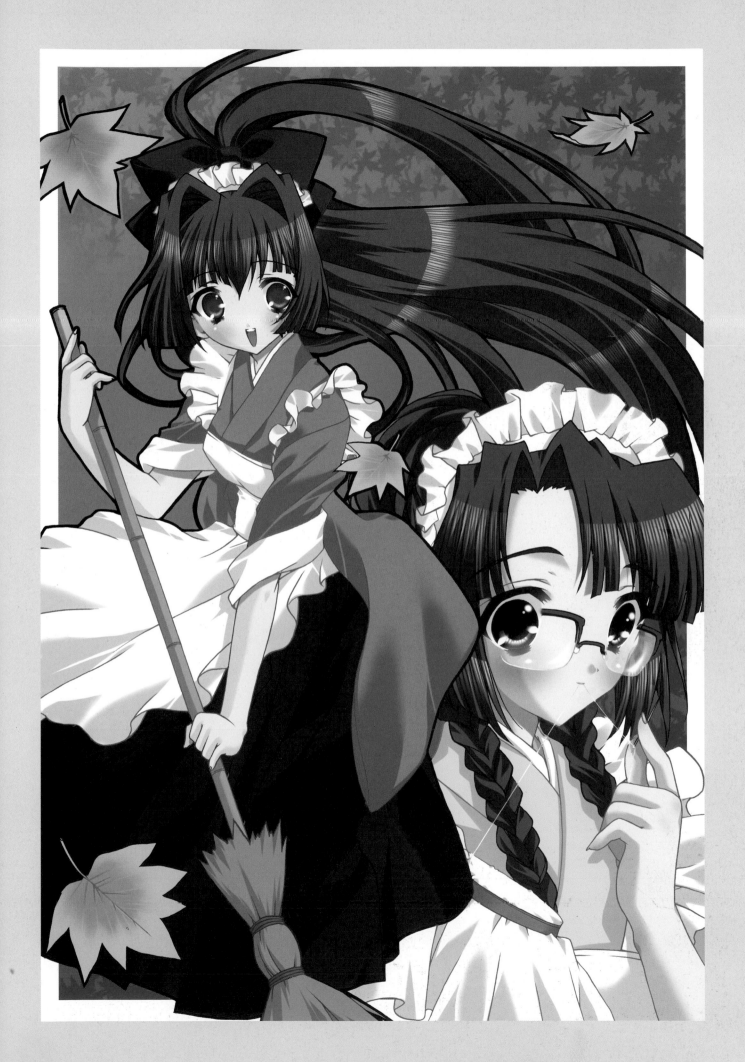

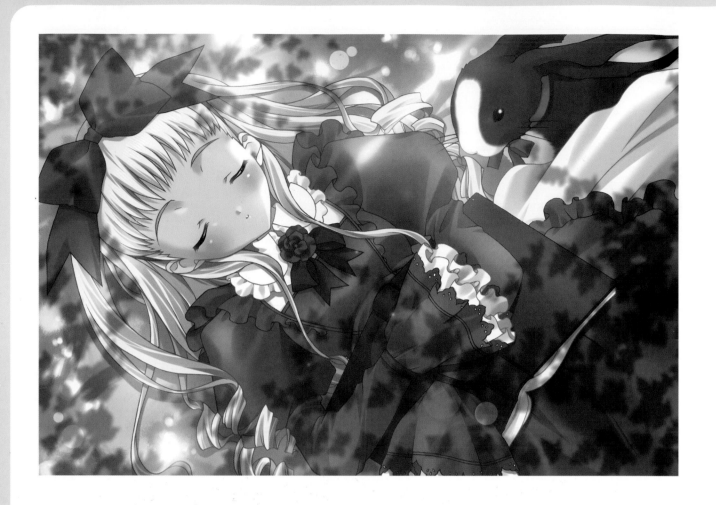

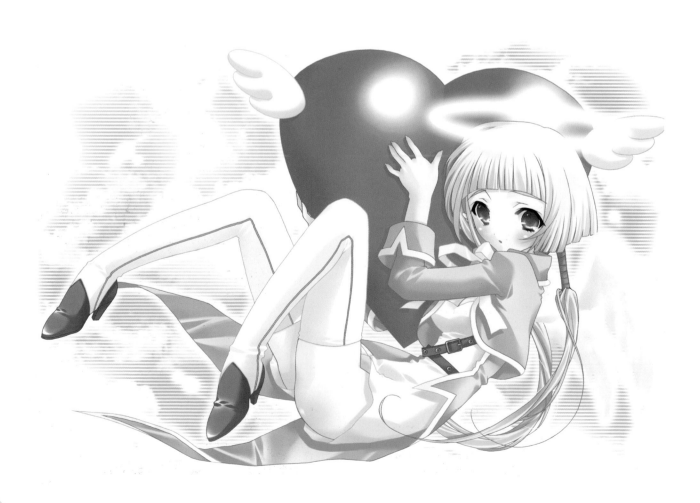

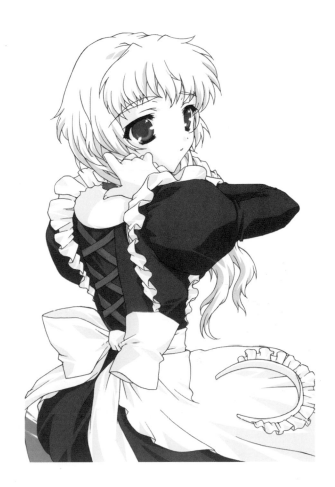

STEP BY STEP

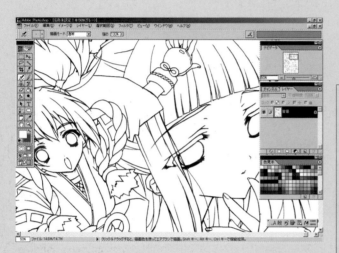

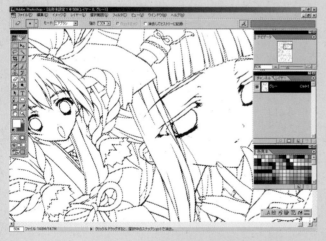

1. Rough sketch scan (1)
First, I scan the pencil sketch into the program. I set the scanner to 350 dpi and grayscale for this picture. The scanned image contains a lot of junk, much of which I can eliminate by doing a level adjustment.

2. Rough sketch scan (2)
I set level values depending on how dark the lines in the original drawing are, so I'm not partial to a particular value. I find that starting with the value at the highest point on the graph and then making fine adjustments works best. I get rid of most of the junk this way, but some small amount still remains. I leave it there and go on to the next stage.

3. Rough sketch correction
I select Load Channel as Selection, then Similar. Next I select Inverse, make a new layer, and fill the selected area with black. Then I deselect the selected area and add a new background layer under it. I no longer need the image I scanned in, so I can now delete it.

4. Completion of rough sketch correction
The lines in scanned pencil drawings always get blurred, so I redraw them using Path and Brush. When doing line correction, I always try to be careful not to further widen lines and to preserve the original variation in line weight and thickness. With that in mind, I redraw the lines, using the Eraser to erase the small junk artifacts that still remain.

5. Basic coloring
I make separate layers for each element of the picture, and paint the base color on each layer.

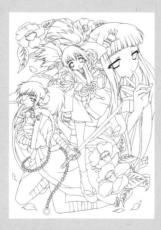

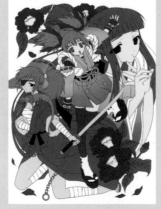

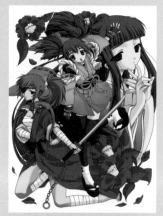
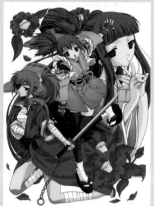

6-1	6-2
7	8
9	10
11	12

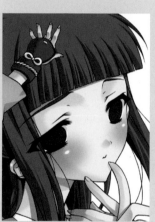
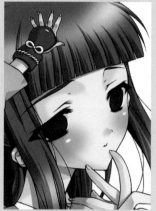

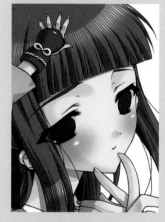
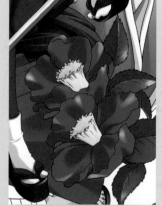

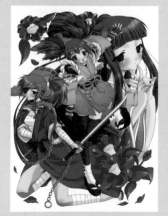
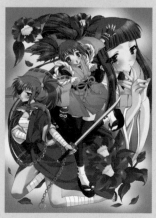

6. Shading: First stage
As I paint In the shading, I group each picture element layer and its shading layer. I want to give the shading contrast, so I paint the basic shading with the Airbrush and then erase any extra. To paint the shading, I start with a solid line and gradually work it out to a soft, blurred edge.
Shading: Second stage
I make a new layer on top of shading (1), naming it shading (2), and add it to the layer group. I paint shading (2) in a darker color than shading (1).

7. Addition of pink skin color
After I finish painting the shading, I make a new layer on top of the shading (2) and add it to the layer group. On the new layer, I paint a pink skin shade on each characters' cheeks, ears, finger tips, elbows, and knees. To make skin tones look natural, I have to adjust the opacity level.

8. Hair highlights
I use the Dodge Tool to make a highlight layer over the hair layer base color.

9. Completion of hair highlights
Everyone has his or her own way of highlighting hair. I make a new layer between the base and shading (1) layers and draw separate lines over the dodged area to represent individual hairs.

10. Other highlights
I use the Dodge Tool to add highlights over the base color layer of other picture elements, in the same way as for the hair.

11. Painting the line drawing
To paint the original line drawing, I use the Brush and Airbrush with the Preserve Transparency box selected. I get a good effect by painting the lines darker than I painted the shading (2). I'm not partial to a certain color; the color I use depends on the picture.

12. Completion
I add a highlight layer over the line drawing layer to highlight the eyes and other spots. Then I make a few minor corrections and put the finishing touches on the picture. Finally, I paint the background. The picture is finished!

Hikaru Nakano

なかの ひかる

Nakano's unique worlds are artfully drawn entirely with pencils in pastel colors.

Colored pencils tend to be used for rough sketches
for illustrations, for minor retouching of details,
or for adjusting the overall tones. It is rather rare to find
colored pencils used to achieve realistic illustrations
such as the works by Hikaru Nakano.
Her techniques are closer to what's traditionally
associated with pastel illustrations. However,
her illustrations convey a clearer aesthetic than
pastel drawings, which may result from the hardness
of the pencil lead.

Hikaru Nakano

Year of birth : 1975

Place of birth : Tokyo

Works appeared in : Comickers

Working Tools

From rough sketches to the final completion, colored pencil only

KMK Kent paper (#200)

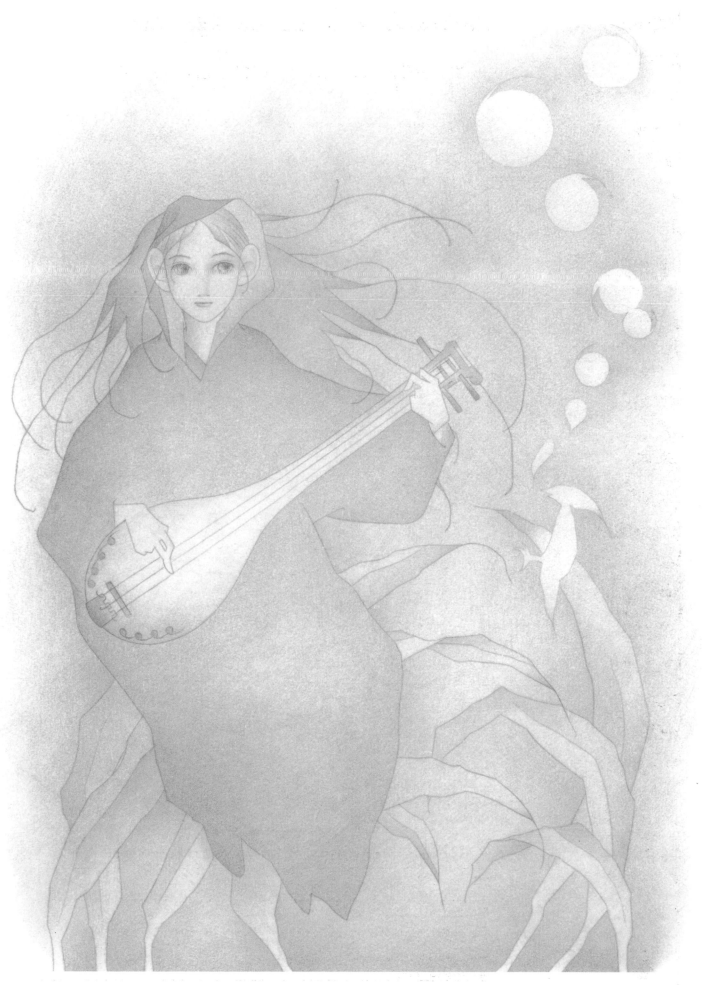

Untitled

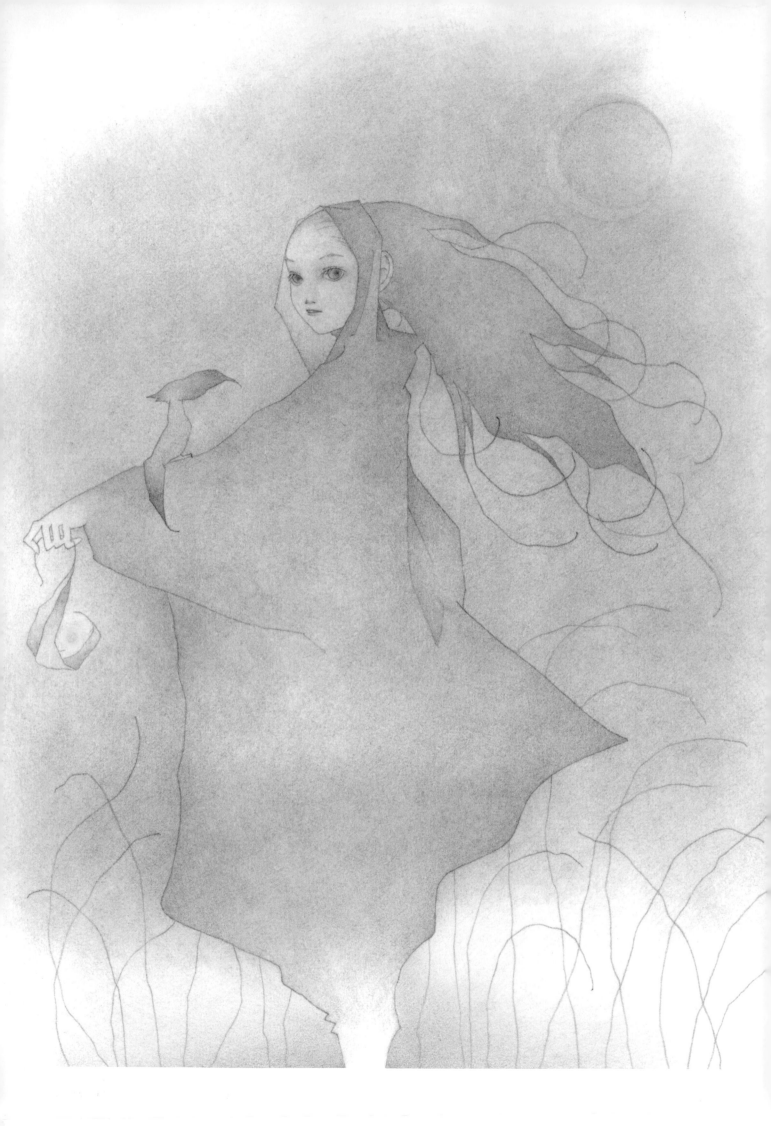

1. Untitled
2. Mama

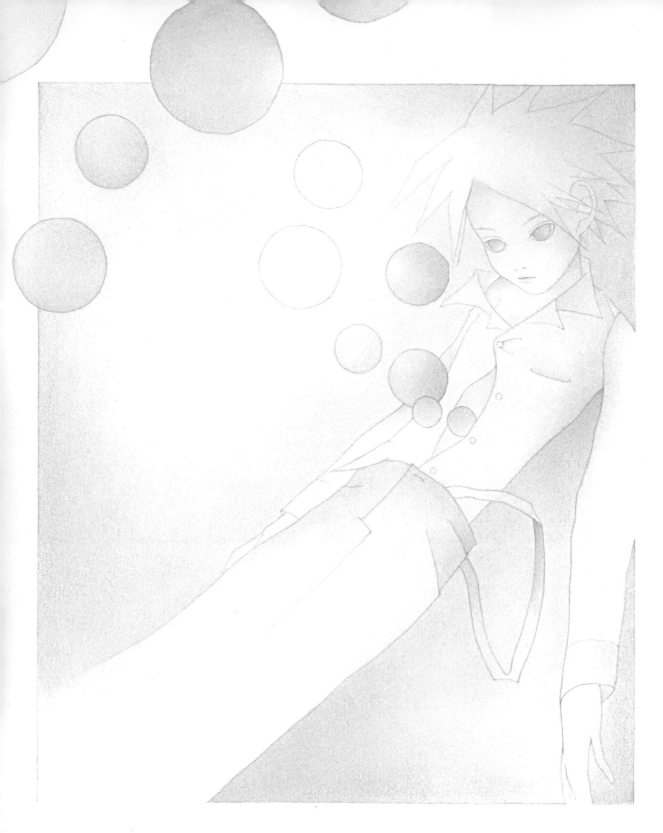

3. WATER

4. blue

5. INVADE

6. MOON

7. re-print

8. Untitled

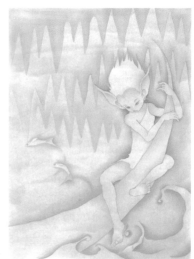

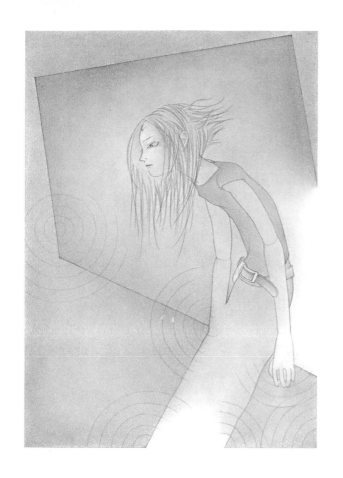

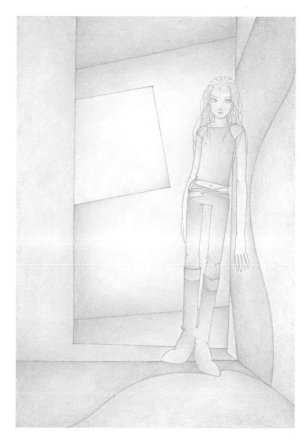

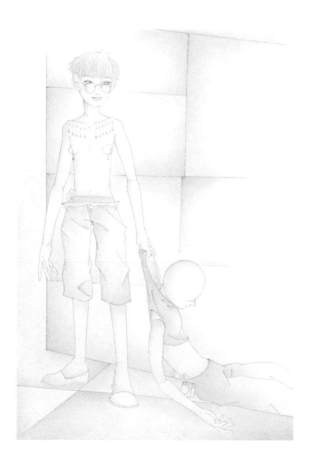

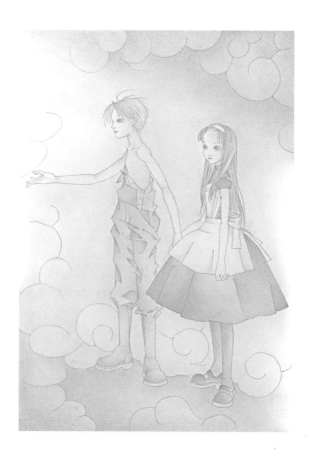

STEP BY STEP

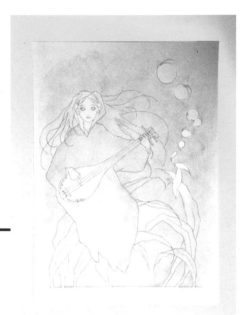

1 I draw the main outline according to the built-up lines.

2 I apply some more strokes to match using a sharp pencil lead.

3 When the colors are applied overall, I scrape the surface with tissue paper and blur the applied area. The tipped edge of the tissue paper folded into small pieces works well for this.

4

Where the colors need to be darker, I repeat the application of colors and scrape with tissue paper as many times as necessary.

5

It is essential that pencil leads are kept hard and sharp in order to achieve the proper clarity of illustration.

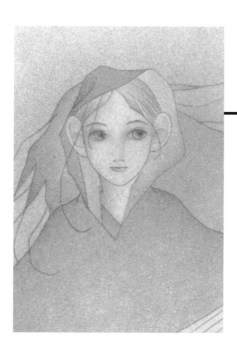

6

Completion.

ridoru.

ridoru makes skillful use of CG filters by stacking them to lend a soft atmosphere to her illustrations.

ridoru does all of her work with a computer and
her artwork highlights the fantastic effects possible using
cutting-edge computer graphics. By using multiple filter
functions in Adobe Photoshop over and over,
ridoru achieves a transparent effect that is
difficult to do by hand. This kind of effect,
once only possible with high-powered,
high-spec machines, can now be achieved more easily
with innovative software such as Adobe Photoshop.

りどる

ridoru

ridoru@da.airnet.ne.jp

http://www4.airnet.ne.jp/ridoru/

Place of birth : Yokohama, Kanagawa

Gender : Female

Works appeared in : Digital Comickers, CG Collection, Swan no Koi (editorial illustration), and others

Working Tools

Main Computer : PowerMac 9500/300

OS : Mac OS 8.1

Memory : 320MB

HDD : Internal/4 + External 8.3+20GB

Applications : Adobe Photoshop 5.0, Adobe Illustrator 8, Painter 6.0J

Accessories : WACOM UD-0608-A, DiamondtronRD17G, MO, CD-RW, and midi and the midi-related.

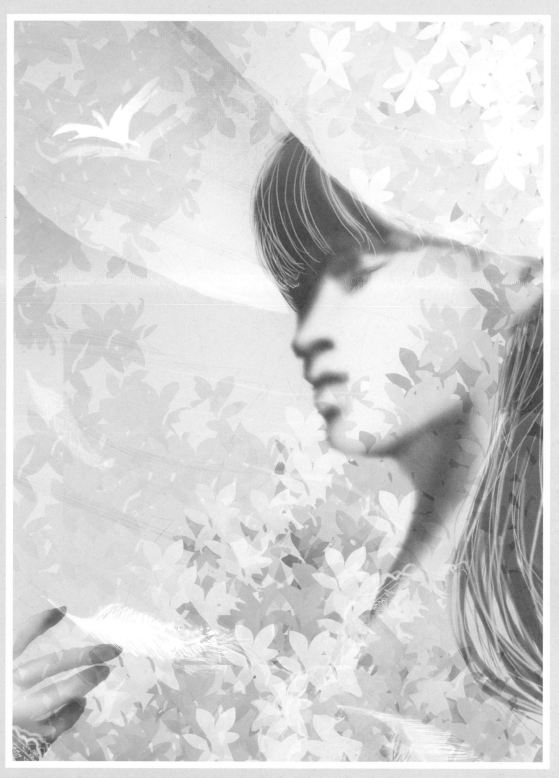

Early Summer

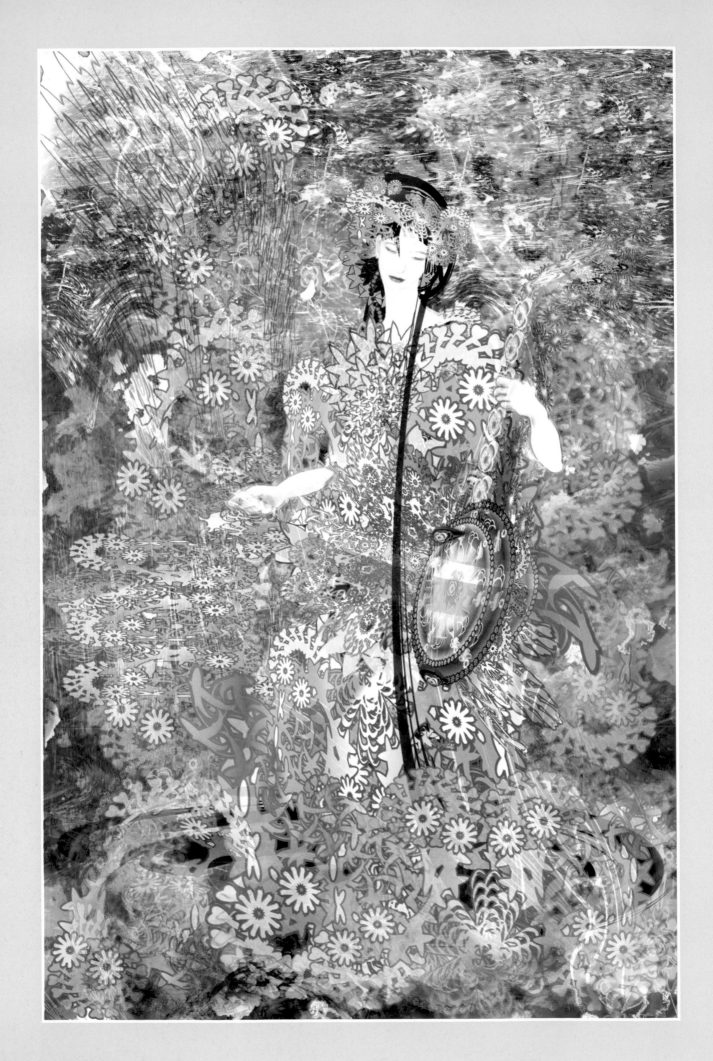

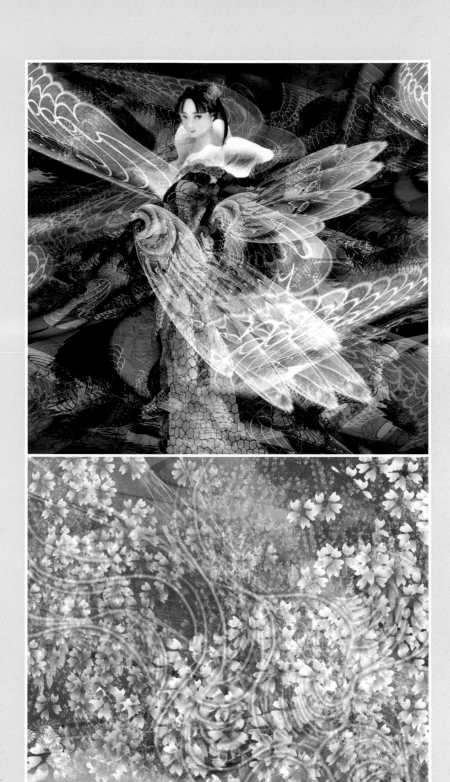

1. Sound Of Spring
2. Snake Princess
3. Sleeping In the Cherry Blossoms

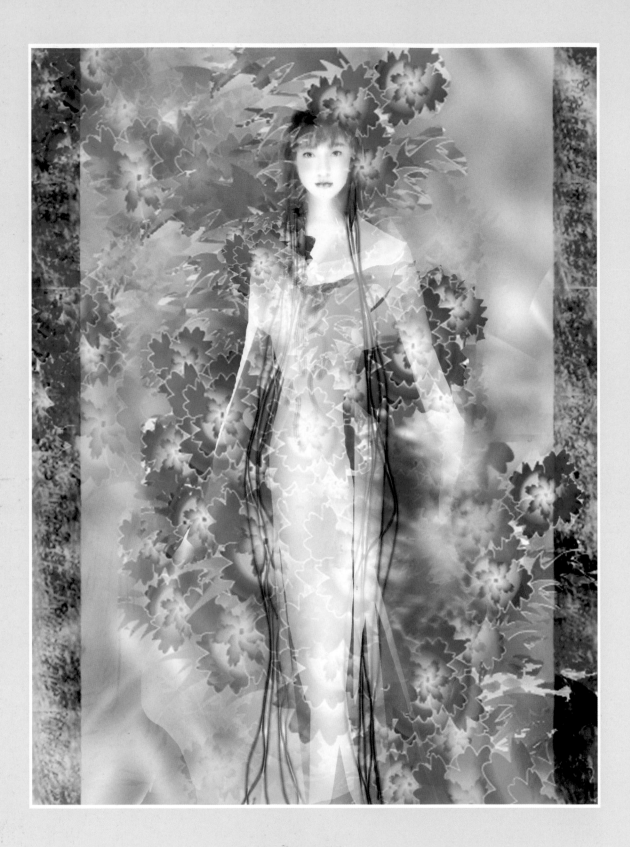

4. Flower Maiden
5. Moon Of Sound
6. Piano
7. Sunny Spot
8. Setting Out With Snow

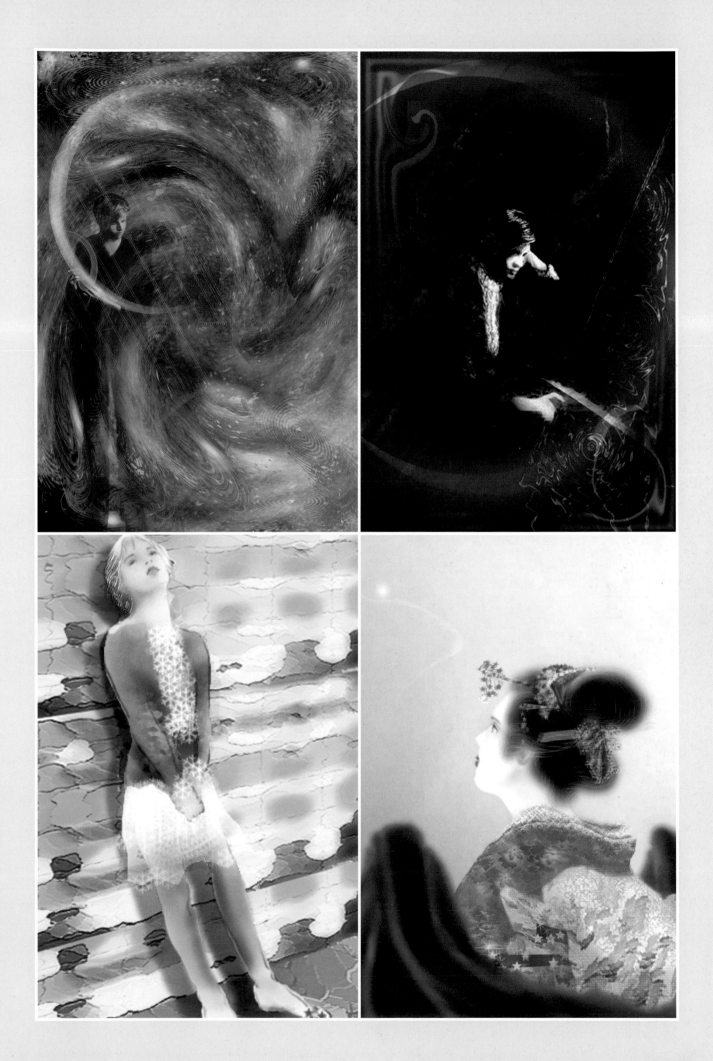

STEP BY STEP

1 I start with background tones, focusing on the main subject of the early summer sky and green areas. My intention is to express the soothing summer breeze and luminous green leaves with blue and green gradation.

2 To draw the fresh green leaves, I create a single leaf first, copy it by changing the brightness, and lay them out.

3 I generate the objects by applying "Sheer" or "Turn round" filters onto the straight-line layers on the front area. Thus, a swaying effect of summer wind is created.

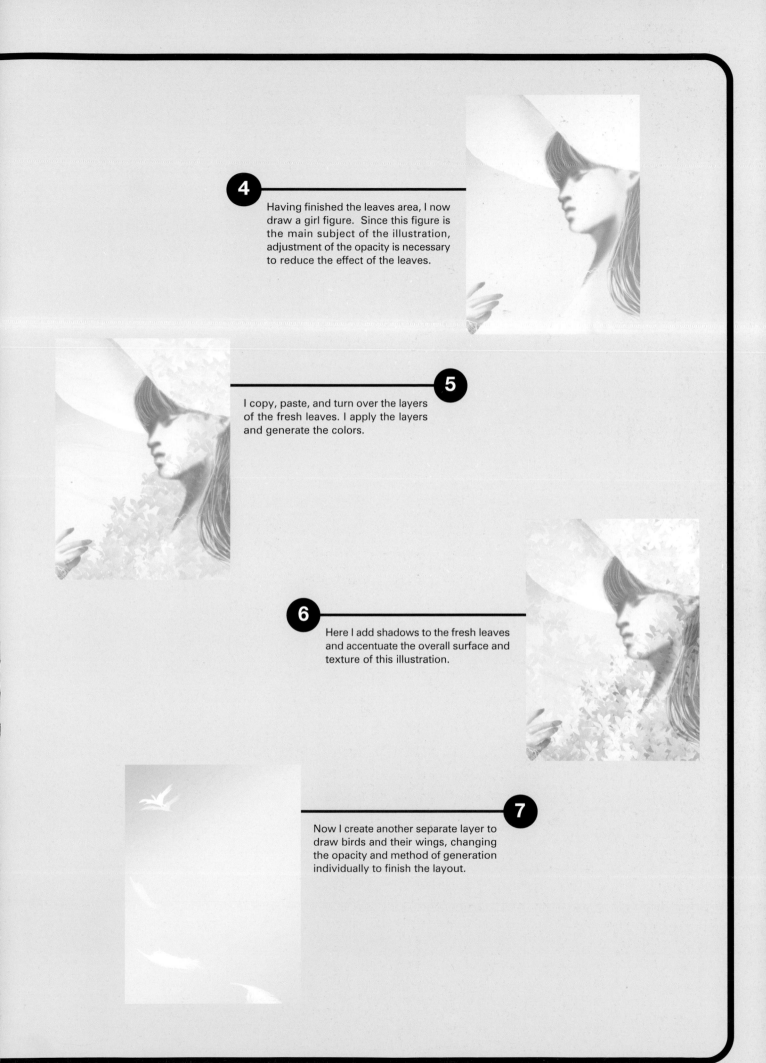

4

Having finished the leaves area, I now draw a girl figure. Since this figure is the main subject of the illustration, adjustment of the opacity is necessary to reduce the effect of the leaves.

5

I copy, paste, and turn over the layers of the fresh leaves. I apply the layers and generate the colors.

6

Here I add shadows to the fresh leaves and accentuate the overall surface and texture of this illustration.

7

Now I create another separate layer to draw birds and their wings, changing the opacity and method of generation individually to finish the layout.

Ryuya

Ryuya's illustrations demonstrate an exceptional feel for the exotic, coupled with fine expressive power.

The following pages will show why Ryuya is so skillful at managing the transparency of pigments. She has created one illustration to be colored with two different art materials. In the first, she uses Liquitex (the regular type) and adjusts the transparency of the colors by adding various amounts of water. In the second, she uses Liquitex Gouache Acrylic; its opacity enables bold over-painting.

流耶

Ryuya
albireo@rocket3.net
http://albireo.rocket3.net/

Year of birth : 1980
Place of birth : Miyazaki
Gender : Female
Works appeared in : Comickers

Working Tools
Liquitex, colored ink, Canson Kent paper, Bredant

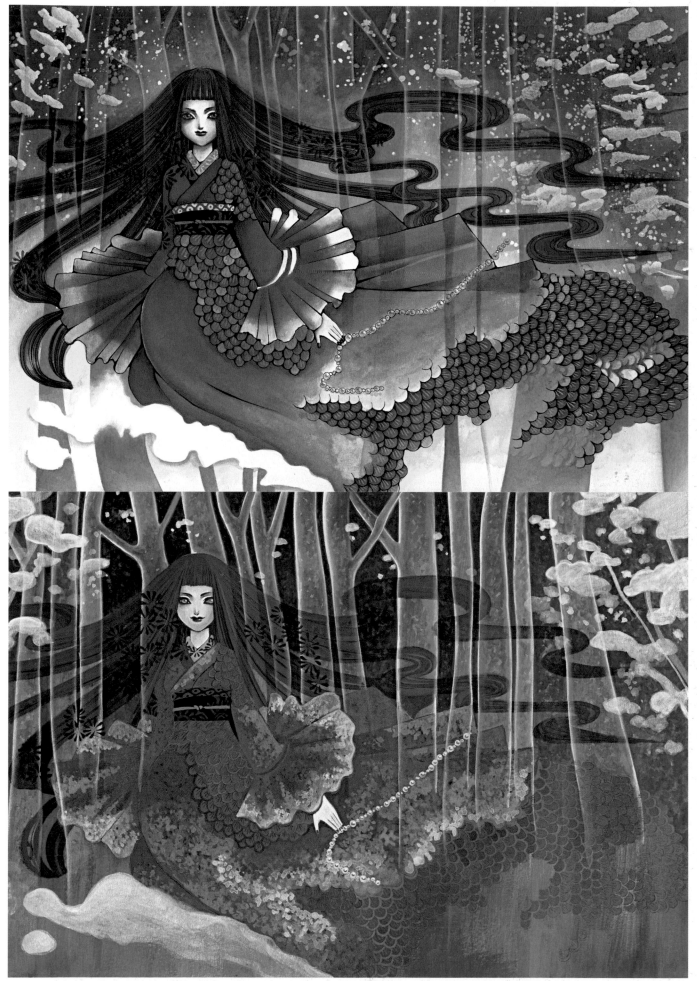

Untitled

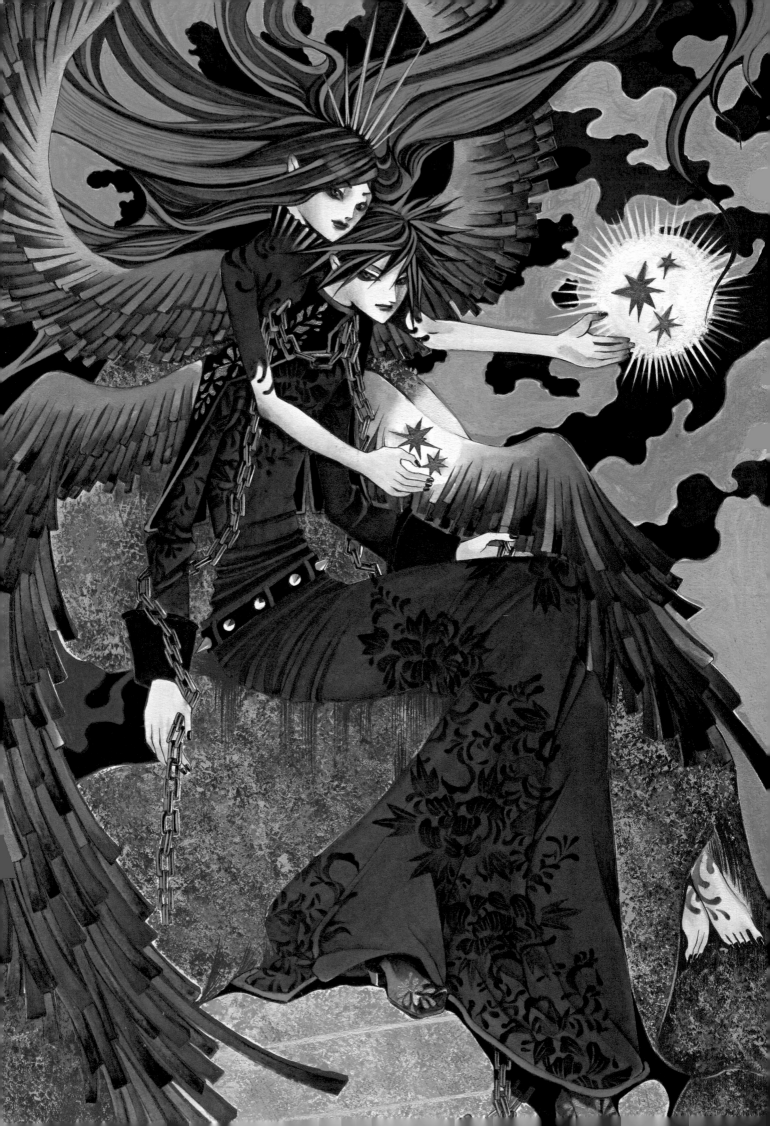

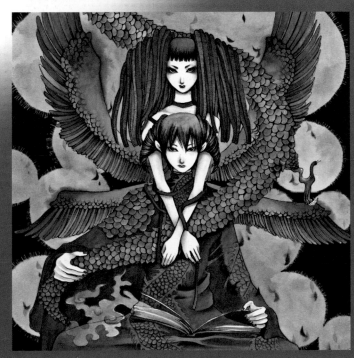

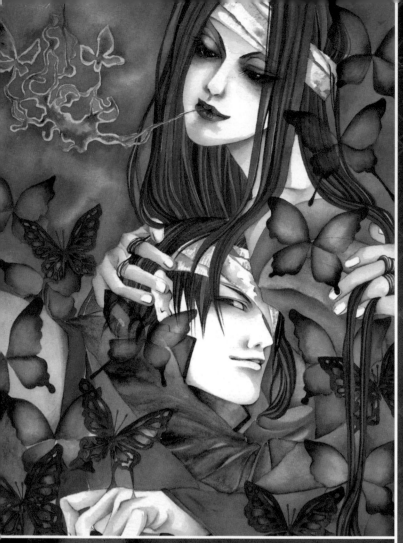

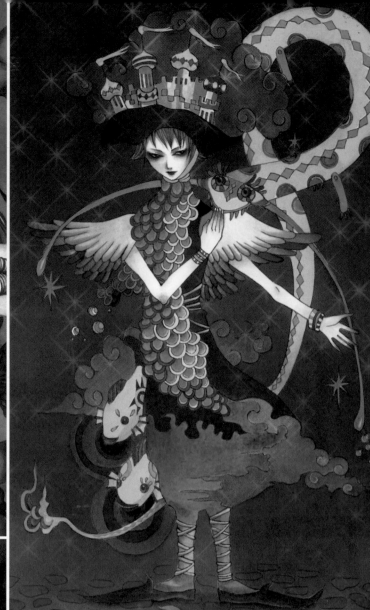

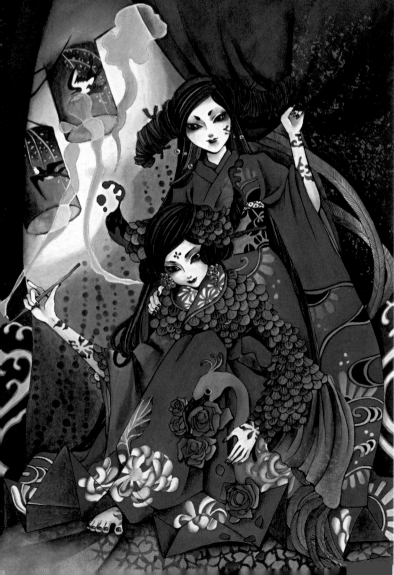

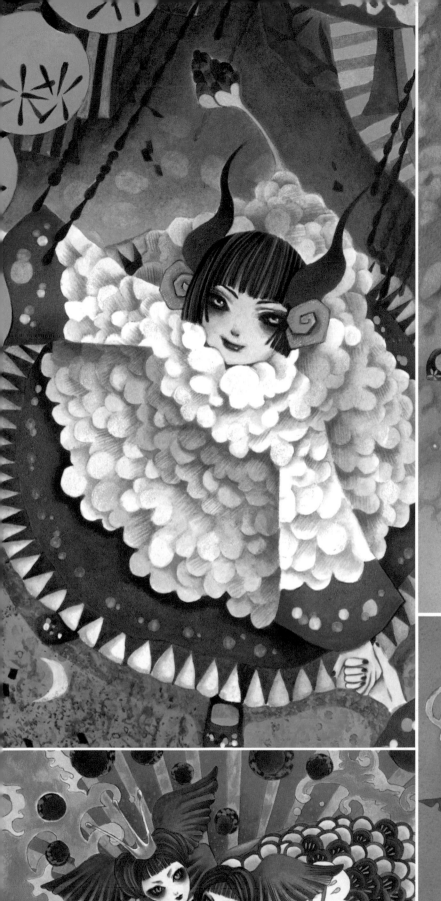

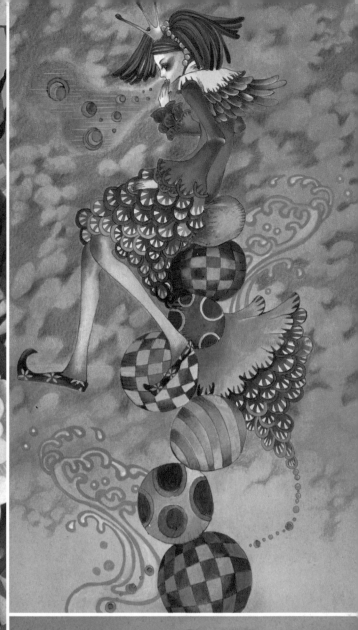

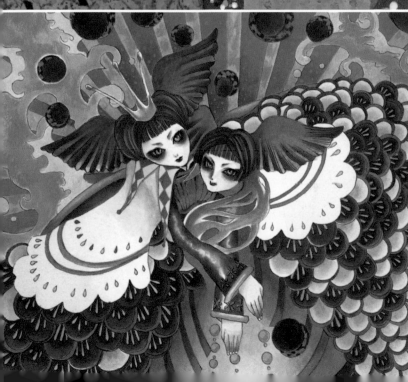

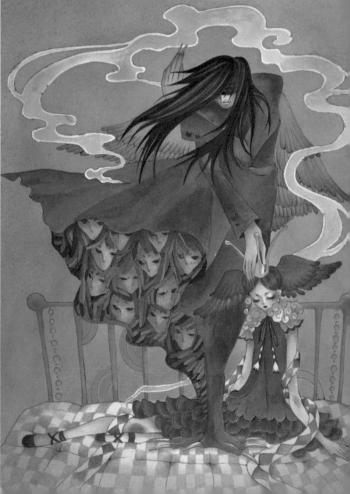

STEP
BY STEP

1	**2**
3	**4**

Liquitex (regular type)

1. First I apply the mixed colors to the rough sketch.

2. I overlay the colors by directly squeezing them out from their tubes. When using normal watercolors, the under colors dilute and become dull and muddy.

3. By using the Liquitex, I can apply multiple sheer layers over and over again, using various mixed colors and a lot of water.

4. Completion.

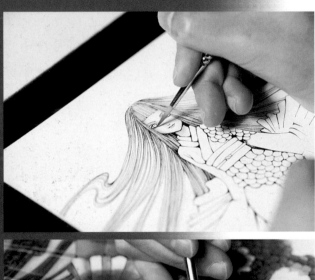

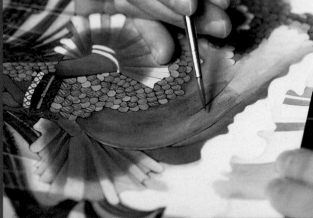

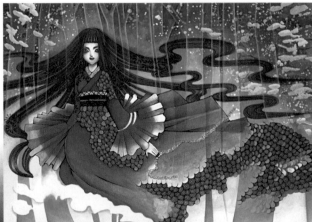

Liquitex Gouache Acrylic

1. Rough sketch.

2. Here I apply the color of Turquoise Deep all over the surface using various brush-strokes.

3. While the first layer of the color is still wet, I add Permanent Yellow...

4. ...and Titanium White to express the texture effect.

5. Now I add more colors to the character's hair and shadow area.

6. Here I add details more precisely.

7. Completion.

	1
2	3
4	5
6	7

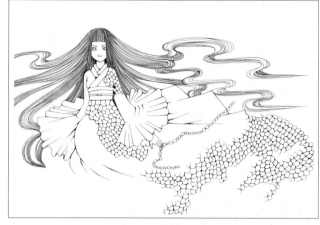

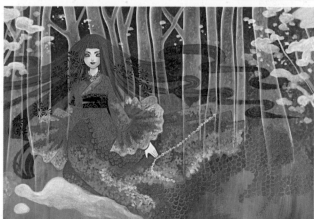

YOKO Tanji

丹地 陽子

Yoko Tanji's colorful illustrations are rendered with an expressive power and excellent eye for composition that belie their computer graphic origins.

Instead of scanning in a drawing done on paper,
the artist draws the picture directly into the computer with a
drawing tablet — a technique that requires a high level of
skill and layout creativity.

Photoshop is not as strong on texture expression as Painter and
other painting applications. But notice the technique
the artist employs to depict the texture of a painter's canvas.

Yoko Tanji's technique of creating images with a minimal use of
layers is one that can be duplicated with Photoshop LE (Limited
Edition) or any other application that supports layers.

Yoko Tanji
yoko@tanji.jp
http://www.tanji.jp

Year of birth : 1970
Place of birth : Ise, Mie
Graduate school : Tokyo University of Art (design major)
Gender : Female
Works appeared in : error #1 (20 pages of the full-colored comic)

Working Tools
Main Computer : Power Mac G4
OS : Mac OS X.2.2
Memory : 1,024MB RAM
Clock waves : 867MHz
HDD : 160GB
Applications : Adobe Photoshop 7.0J, Adobe Illustrator 10J, Painter7.0J
Accessories : Tablet/WACOM Graphics Tablet GD-1212, Printer/HP Deskjet1125C, Scanner/EPSON GT7600U

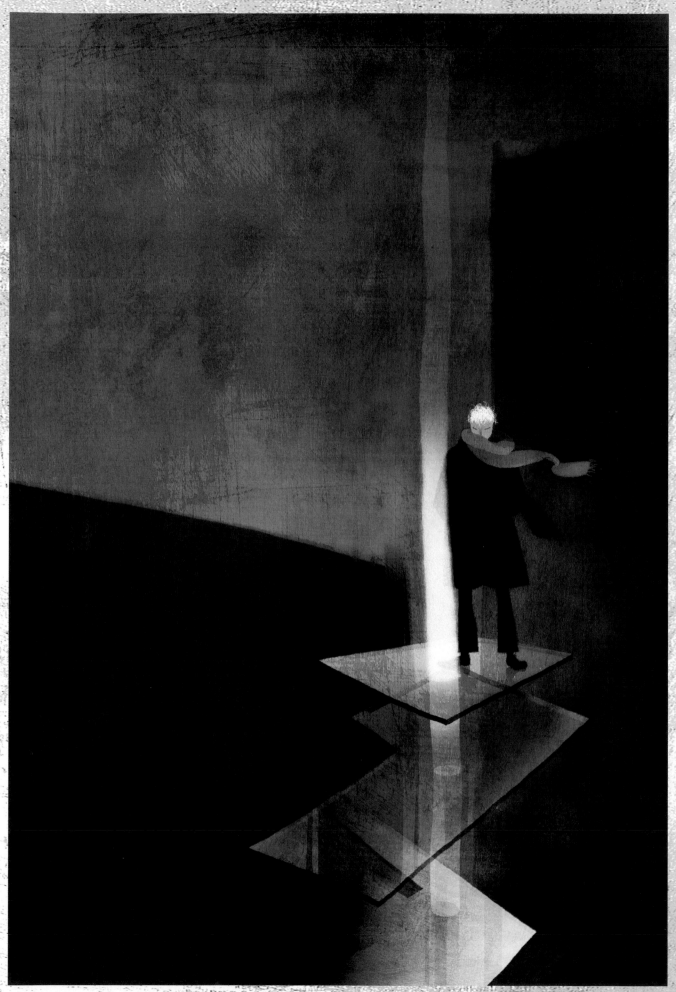

Untitled

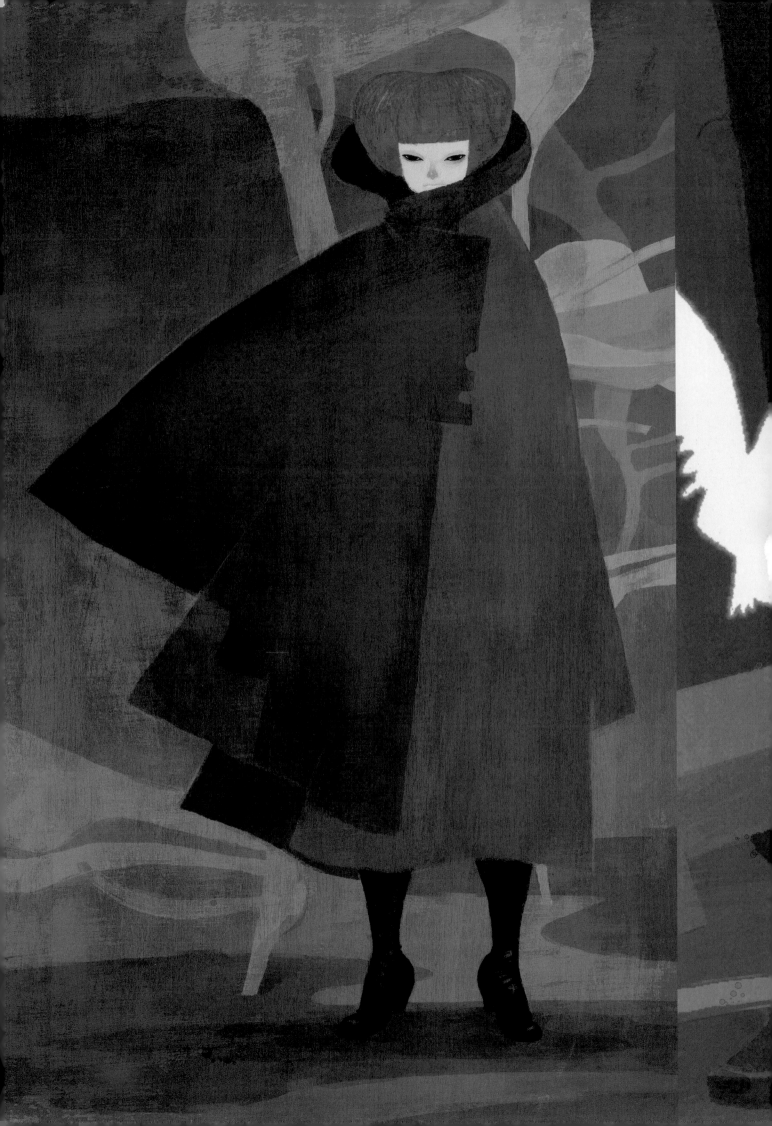

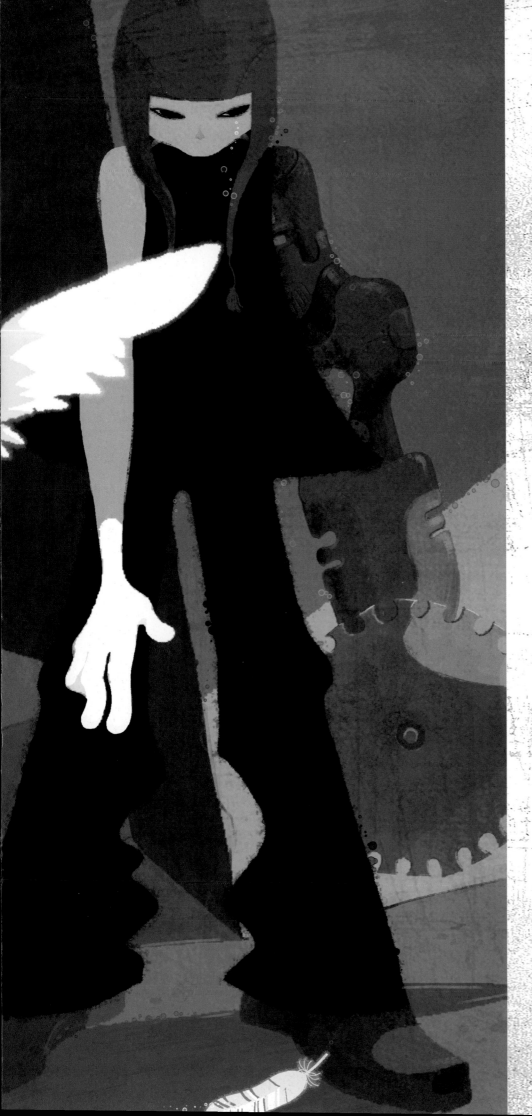

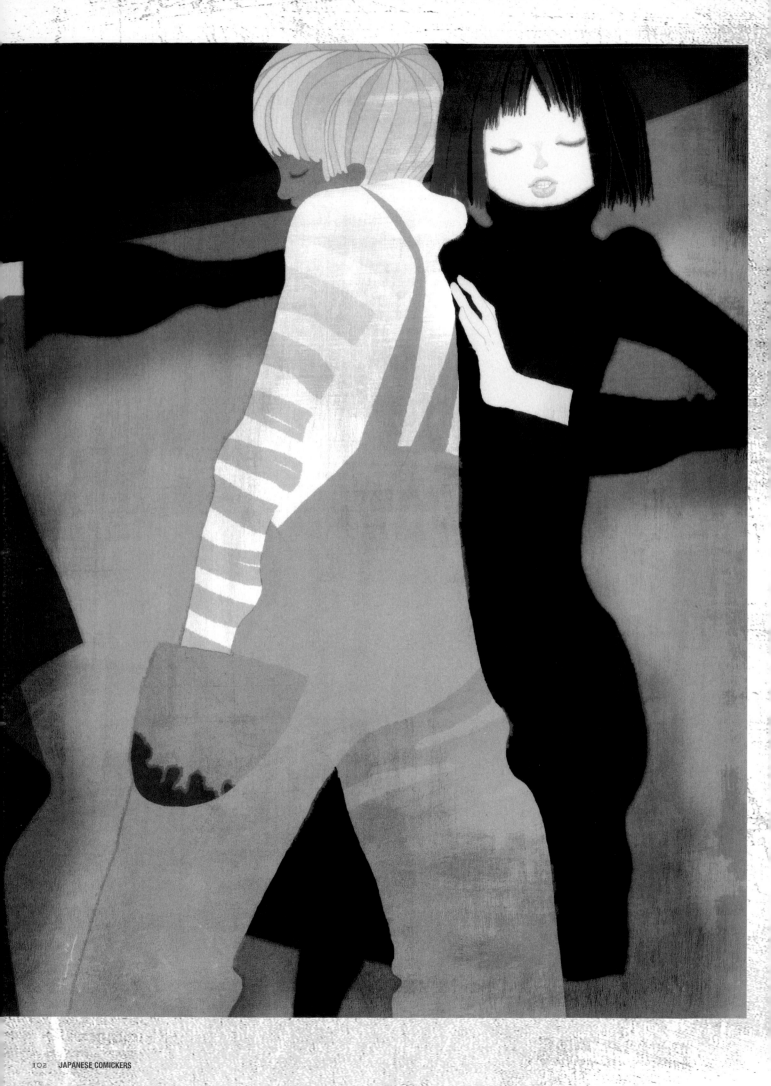

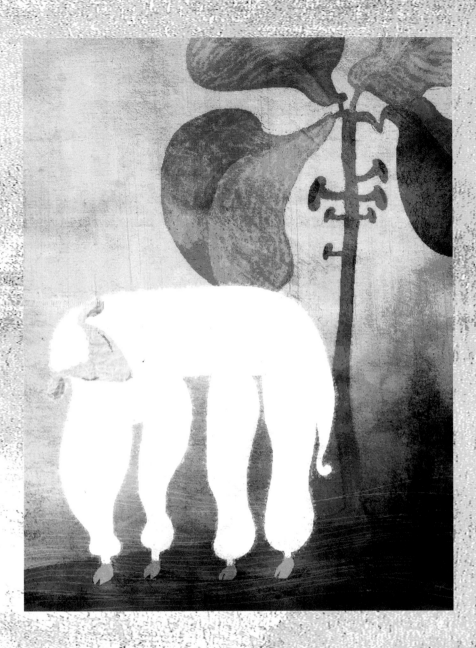

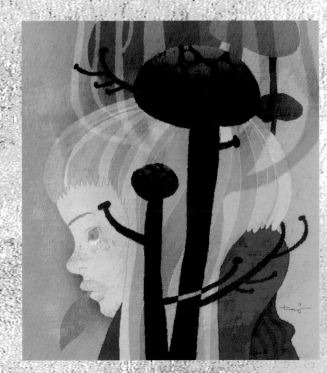

3. Untitled
4. Untitled
5. Untitled

STEP BY STEP

1

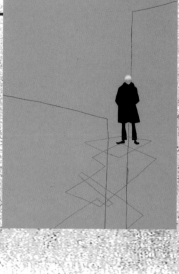

My drawing expresses the themes of "absolute solitude" and "philosophy," so I decided to create a space and place a small character in it. I painted the picture in shades of blue to express loneliness. I rarely do a rough sketch on paper. Instead, I draw directly into the computer at low resolution.

First I set resolution at 72 dpi and create a file. I begin drawing using the Pencil Tool. I may or may not use layers for an image.

After working out the composition and forms, I increase resolution to what I will use for the final image. I set this picture at 300 dpi.

I smooth jagged sketch lines with the Pencil Tool.

2

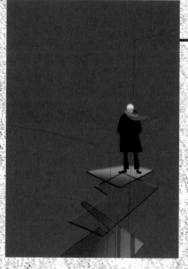

I use the Gradient Tool to draw the sheet glass, and paint it to look natural. I darken the background in order to make the glass stand out.

3

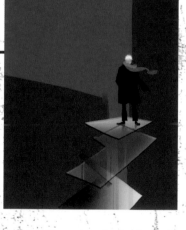

Next I paint in the background.

4

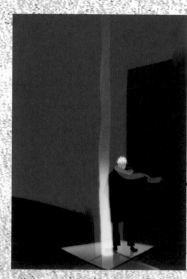

I add a pillar of light. I use Overlay and Hard Light in the Layers Palette to achieve the effect of light.

STEP BY STEP

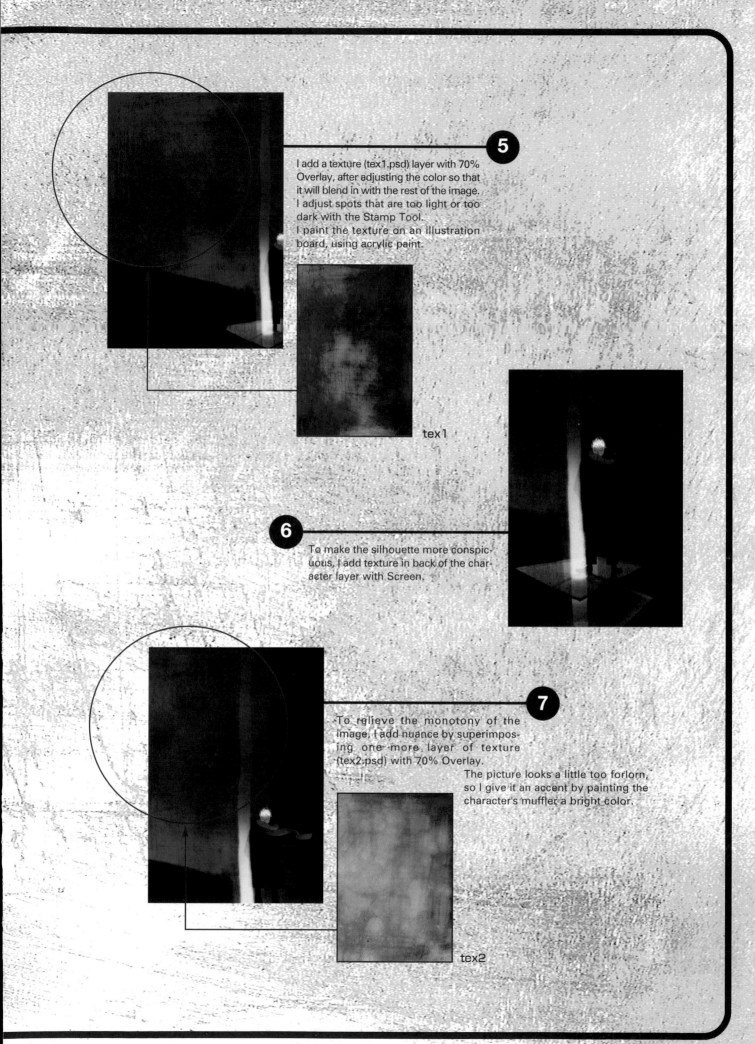

5

I add a texture (tex1.psd) layer with 70% Overlay, after adjusting the color so that it will blend in with the rest of the image. I adjust spots that are too light or too dark with the Stamp Tool.
I paint the texture on an illustration board, using acrylic paint.

tex1

6

To make the silhouette more conspicuous, I add texture in back of the character layer with Screen.

7

To relieve the monotony of the image, I add nuance by superimposing one more layer of texture (tex2.psd) with 70% Overlay.
The picture looks a little too forlorn, so I give it an accent by painting the character's muffler a bright color.

tex2

Mey suzuki.

すずき めい

Suzuki focuses on the popular combination of mecha and pretty girls in colorful illustrations that are suggestive of cel animation pictures.

The possibility of the computer crashing or freezing is a constant challenge for computer graphic artists working with large files using multiple layers. Mey Suzuki has developed a good technique to address this challenge. His method is an interesting contrast to the one developed by Yu Kagei, who does most of her illustration work with gray scales while maintaining minimum layers.

Mey Suzuki	
Year of birth : 1972	
Place of birth : Tokyo	
Graduate School : Musashino Art University	
Gender : Male	
Works appeared in : Orbital AGE (Comic GUM)	
Working Tools	
Main Computer : Self-assembled	
OS: Windows 2000sp2	
Memory : DDR1G	
Clock waves : Athlon1.3G	
HDD : 160 GB	
Applications : Adobe Photshop5.5	
Accessories : Tablet, scanner	
Video card (win) : Matrox Millennium G200	

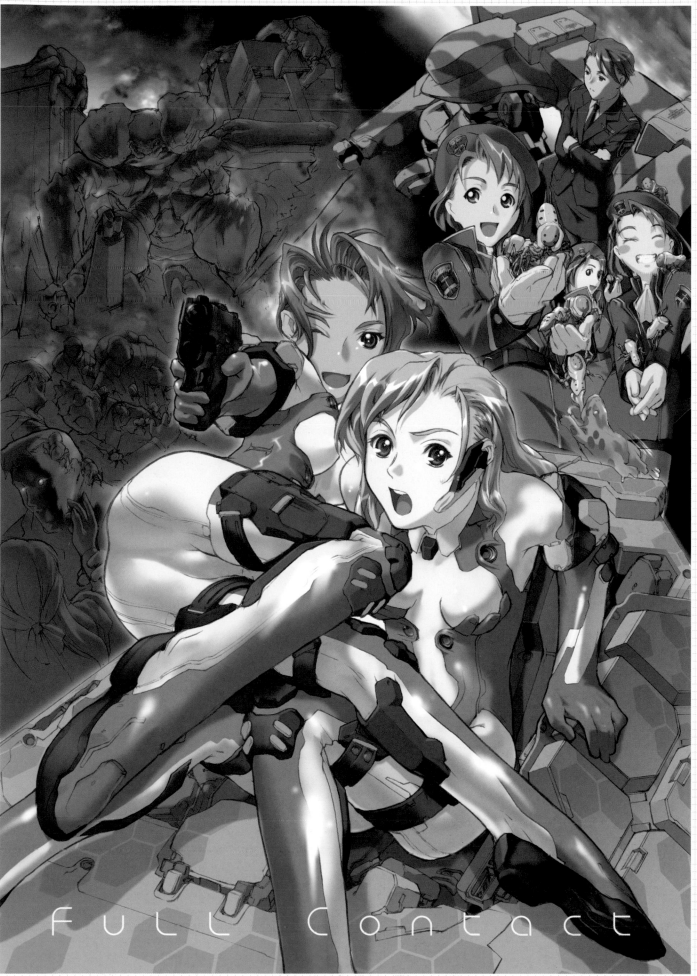

FULL Contact

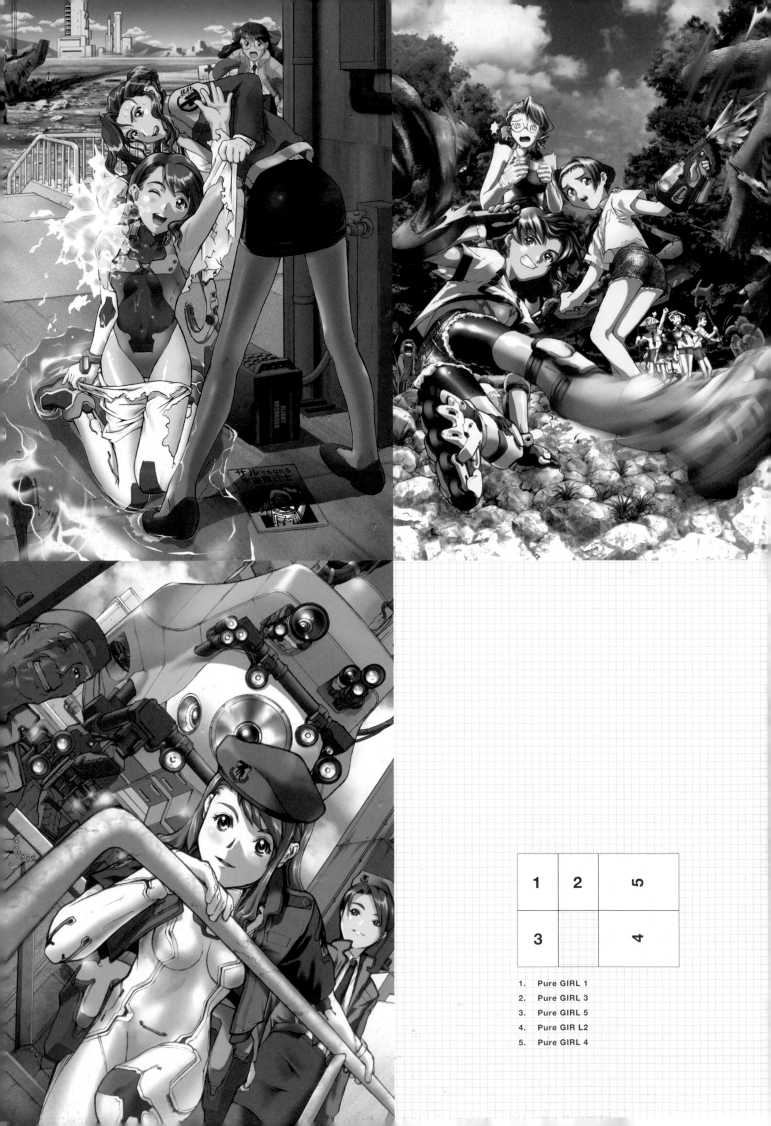

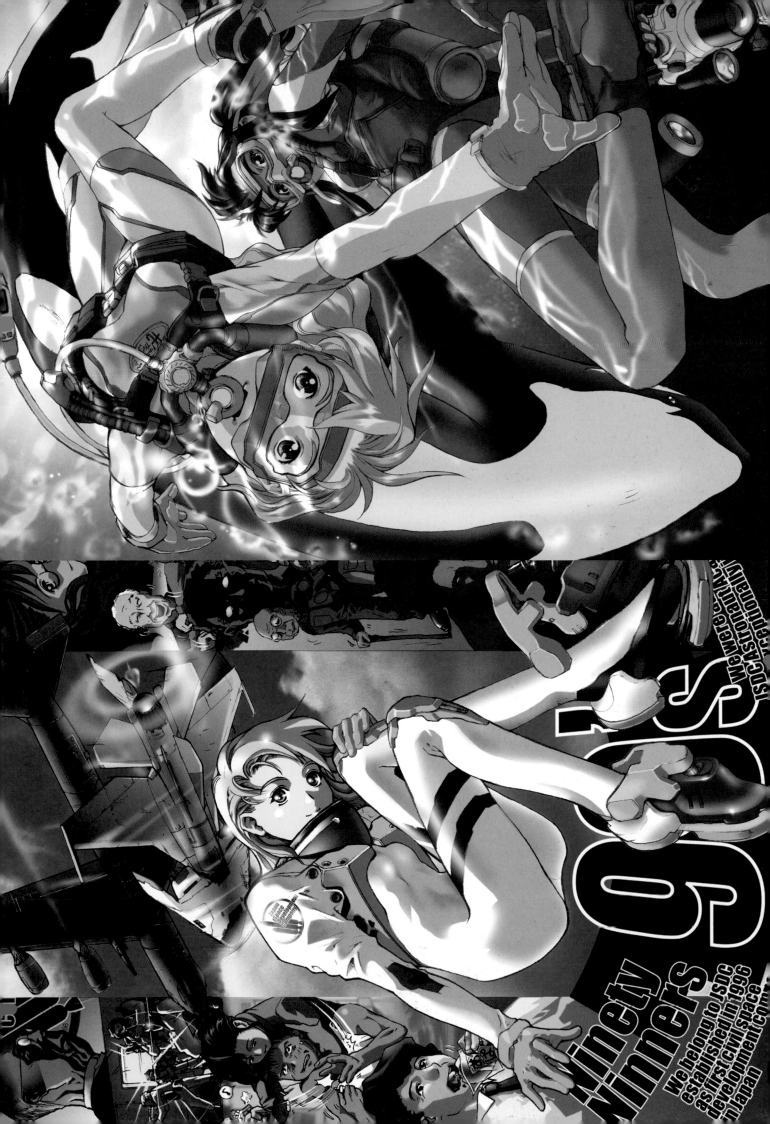

6. CGH 2
7. CGH 1
8. CGH 3
9. TTIS-A~1

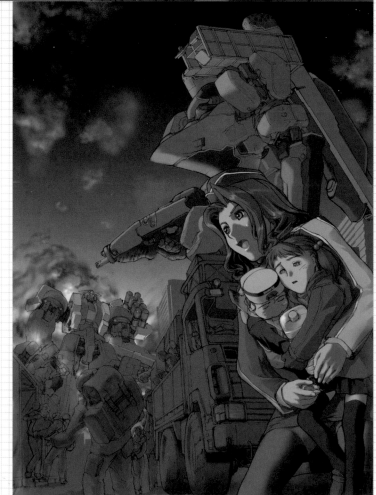

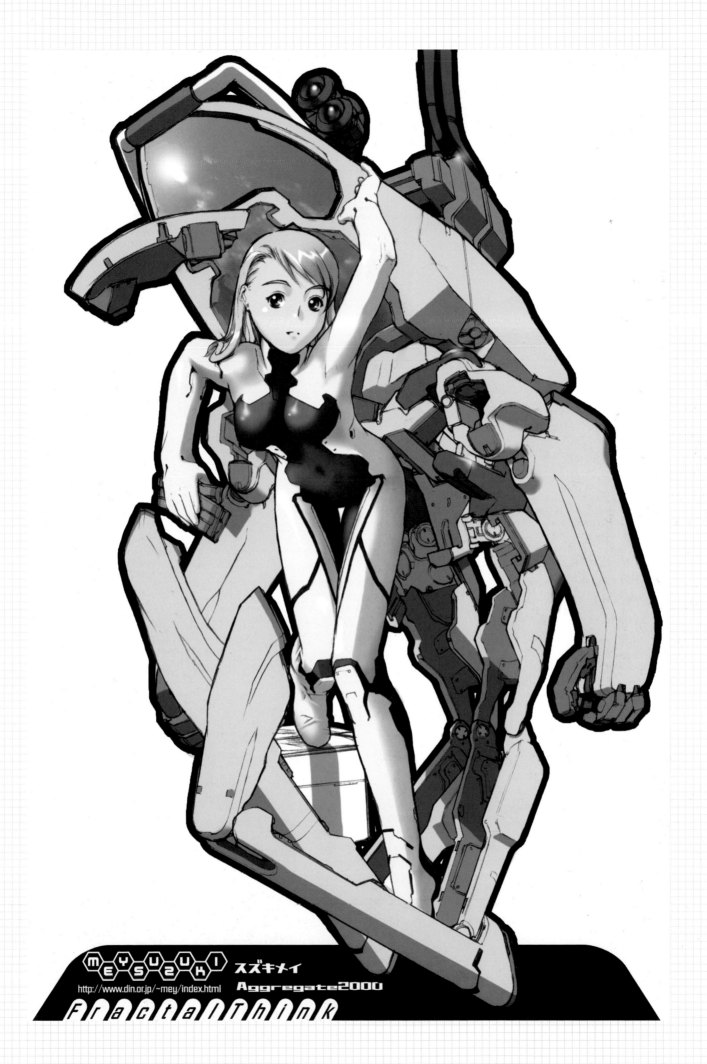

MEYSUZUKI スズキメイ
http://www.din.or.jp/~mey/index.html Aggregate2000
FractalThink

STEP BY STEP

1

I create a rough sketch working with a low-resolution file (around 144 dpi.) I follow the outline of the rough sketch and create separate layers according to the elements of the illustration, such as the hair, costume, and others. I apply the colors on all layers respectively.

2

Note that the shadow colors for each element must be separated individually. This makes later steps easier; if I don't like the colors, I can change them by adjusting the color balance or hues and brightness in the palette.

3

When I have finished applying the color, I prepare the high-resolution outline drawing and place the color layers by increasing the resolution one by one.

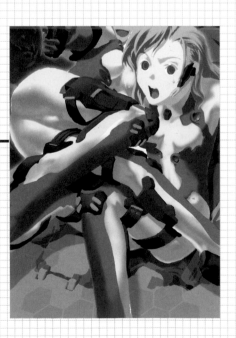

4

After this process is done, I adjust the color of the main drawing lines according to the wash area of the colors. Alternately, I blend the border of the colors.

5

At this stage, my computer running speed is often very slow and I am beginning to lose my patience. But I should not compromise and not be tempted to assemble layers at this stage. By leaving the multiple layers as they are, the final color adjustments are much more flexible.

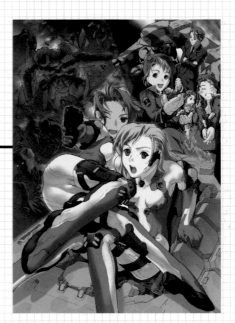

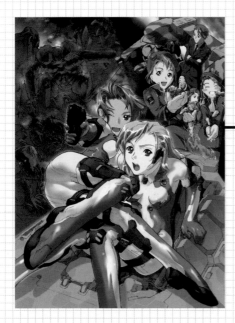

6

Add highlight. Completion.

Ippei · Gyoubu

形部 一平

Ippei Gyoubu creates unique pop art illustrations with Illustrator.

Although most digital artists favor software applications that include photo-retouch functions, Ippei Gyoubu is one of those creators who is still fond of Adobe Illustrator. A lot can be learned from his exceptionally clever technique of using the path-tool application.

Ippei Gyoubu

Year of birth : 1974

Place of birth : Osaka

Graduate school : Kobe Art and Technology of University

Gender : Male

Representative Work : Character design for "Cool Cool Toon,"

the application specifically for DreamCast by SNK Corporation (2000)

Works appeared in : Big magazine #32 "GAME" (2000),

Zoo #09, 10, 12 (published by Purple House Ltd., 2001-2002),

Comickers (Published by BSS, 2000 Summer issue/2001 Spring issue).

A serial comic work "planet of the fusion" since 2001,

also a serial comic "SPUNKY A GO-GO" appeared in Mammoth (KneeHigh Media).

An advertising illustration for adidas MANGA FEVER (published by Asuka Shinsha, 2002)

Working Tools

Main Computer : Apple Power Macintosh G4

OS : Mac OS 9.0.4

Memory : 640MB

Applications : Adobe Photoshop 6.0, Adobe Illustrator 8.1

Accessories : Scanner/Epson GT-7700U, Tablet/WACOM Tablet, Printer/Epson PM-770C

A Hero Is A Melancholy

Planet of the Fusion

STEP BY STEP

1 First, I scan a preliminary drawing into Photoshop and do basic coloring. Then I start up Illustrator, input the document size in Document Setup, and use the Place command to transfer the drawing to the document.

2 I trace the lines in the drawing with the Pen Tool. I begin with the element I want to be the focal point. In this way, I am able to place all the other picture elements in proper balance with the focal point.

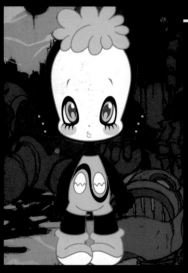

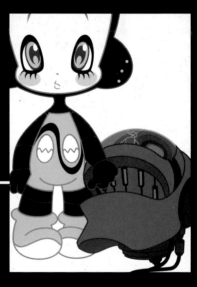

3 After I trace the hero, I trace the head of the robot he holds and place it in the picture under his hand. To do this, I have to allow for front and back positioning of the objects relative to each other. If the objects don't fit together coherently, I draw in the part that's missing on top.

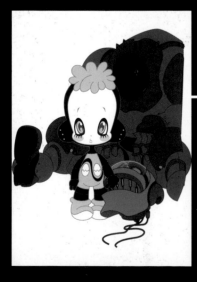

4 I trace the body of the robot. It will be in back of the hero, so I paint it a dull color for contrast.

5 I trace the robot's wiring and the buildings in the background. I don't draw a detailed background-just a silhouette-because it's only an accent in the picture design.

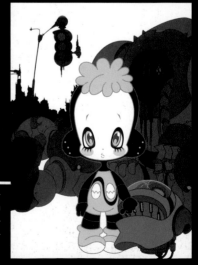

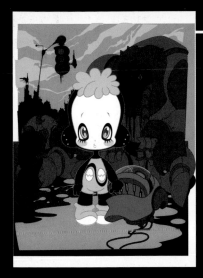

I continue drawing in the background using the same color, and change the color of the clouds for accent. To make the oil look sticky, I convey its surface tension with light shading details.

7
I draw reflections of the clouds in the oil puddle. This is accomplished by selecting and inverting the part of the image to be reflected and adding it to the oil puddle with the Intersect command in the Pathfinder palette.

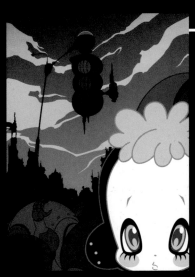

8
To add depth to the image, I fill in the background with a gradient, making sure to maintain the picture's overall balance.

9
To depict the gruesomeness of the battle with the robot, I place random droplets of oil to the head, carefully drawing each droplet to look like a robotic equivalent of blood.

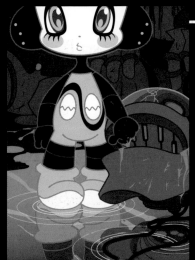

10
I draw the character's reflection and ripples spreading out from his feet in the oil. For the reflection, I use a light color related to the character's coloring so that it blends well with the color of the oil. This detail prevents the hero from fading into the busy background.

11
I add detail and adjust the color. Then I make an object the size of the document and use the Mask command to get rid of the part that ran over the edges of the picture. This is the finished picture.

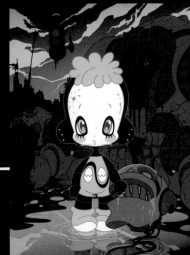

GLOSSARY

Anime and manga terms, titles, and artists' names

Adobe Illustrator® (term)
A vector graphics application that supports Bézier curves. It is marketed by Adobe Systems Incorporated. Illustrator is widely used by designers and publishers to create text and color layouts.

Adobe Photoshop® (term)
Image-editing software with photo retouch capability, marketed by Adobe Systems Incorporated. Photoshop is fast becoming a standard in commercial and doujinsha publishing in Japan.

Akira (title)
Classic science-fiction manga by Katsuhiro Otomo set in a post-apocalyptic Japan, 30 years after World War III. Remarkable for its tremendous detail and imaginativeness, *Akira* has remained a best-selling and influential manga in both the United States and Japan, and has provided inspiration to countless subsequent creators. In 1988, *Akira* was adapted into an animated feature film which is still widely considered the finest example of the anime genre.

Hideaki Anno (name)
Animator. Anno gained fame as the director of *Evangelion*. He is also known for his animation work on the God Warrior in *Nausicaä of the Valley of Wind* and the rocket launch scene in *The Wings of Honneamise*.

Bézier curve (term)
A method of displaying curves by defining them with end points called anchor points. The Bézier curve technique is used in vector graphics applications such as Adobe Illustrator, as well as to create fonts.

Color ink (term)
Watercolor ink. Popular brands in Japan and the U.S. include Holbein, Winsor & Newton, and Dr. Ph. Martins.

COPIC (term)
Fast drying,double-ended,non-toxic markers marketed by Too Corporation. COPIC markers feature beautiful color, durability, and a huge selection of colors. There are 214 colors in the original COPIC series, 298 in the COPIC Sketch series, and 144 in the COPIC Ciao series.

Corel Painter (term)
Graphics software that simulates traditional painting materials.

Tsukasa Dokite (name)
Animator who made a name for himself with his work on *Urusei Yatsura* (aka *Those Obnoxious Aliens*). Dokite also designed the characters for *Dirty Pair*. He is popular for his depiction of stylish characters drawn in soft lines. Currently, he is active as an anime director.

Doujinshi (term)
Self-published books or booklets of manga or any of a broad range of subjects related to manga and anime. There is a strong amateur fan element associated with this type of publication, although many people-called *sengyo doujin* (coterie publication specialists)-make a living publishing *doujinshi*. Some publishers, film companies, or other companies that are copyright proprietors grant subsidiary rights for exclusive use by doujinshi, a practice that has had a profound economic effect on the fan (or "*otaku*") market. The *doujinshi* market is conservatively estimated to be an 800 million US dollar industry.

Evangelion (aka *Neon Genesis Evangelion*) (title)
A TV animation series produced by Gainax and originally released in 1995. Acclaimed for its fast paced direction, elements of mystery, religious symbolism, well-defined characters, and controversial ending, *Evangelion* is regarded as one of the pinnacles of anime and a genuine social phenomenon.

Figure (term)
A word originally used to mean "shape" or "form." The term is often used to designate toy dolls made to resemble manga and anime characters.

Gundam (aka *Mobile Suit Gundam*) (title)
TV animation series that debuted in 1978. *Gundam* immediately attracted attention for its realistic portrayal of battle scenes between giant robotic weapons called mobile suits. Model kits of robots featured in the series soon became wildly popular. Sequels, alternate sagas, and games based on the ever-popular series are still being released.

Shinya Hasegawa (name)
Animator. Hasegawa directed animation for *Evangelion*, *Utena*, and *Sailor Moon* (aka *Pretty Soldier Sailor Moon*).

Ichiro Itano (name)
Animator. Itano is an authority in the field of mecha animation. He is particularly well known for his lightning speed air combat scenes, exemplified in *Macross* (aka *Superdimensional Fortress Macross*).

Yoshinori Kanada (name)
Animator. It is no exaggeration to say that Kanada built the foundation upon which today's Japanese anime stands. His unconventional, acrobatic style of animation features original effects that have been dubbed "Kanada effects."

Layer (term)
A function of photo retouch applications that allows an image to be adjusted and edited in layers, similar to the way animation cels are manipulated. Originally, only Adobe Photoshop supported the layer function. Now, however, it has become standard, and is a feature of most photo retouch and paint tool applications.

Adobe Illustrator 10
Japanese version

Dr. Martins color ink

COPIC

Staedtler watercolor pencils

Faber-Castell watercolor pencils

Limited animation (term)

In contrast to full animation, which uses 24 frames per second, limited animation uses only 8 frames per second. Osama Tezuka first introduced the technique when he adapted his *Astro Boy* manga for television in order to compensate for tight budget restraints.

Haruhiko Mikimoto (name)

Animator and manga artist. Mikimoto's character designs for Macross catapulted him into the spotlight. He has also worked on several other anime, including *Gunbuster* (aka *Aim for the Top*). His latest creation is the computer generated animation *Rayca*.

Jean Giraud Moebius (name)

A dominant figure in the French *bande dessinée* (comic strip) genre. Hallmarks of the Moebius style are shading with intricate combinations of fine lines and original expressions of texture. In Japan, he is known for the strong influence he has had on Katsuhiro Otomo, and for illustrating the package for the Sega game *Panzer Dragon*.

Koji Morimoto (name)

Animator and anime director. Morimoto won acclaim for his work as the assistant animation director on *Akira*. His directing credits include *Memories* and *Noiseman Sound Insect*. He is currently at work on a full computer generated animation adapted from the manga *Tekkonkinkurito* (aka *Black and White*).

Yuji Moriyama (name)

Animator. Along with Tsukasa Dokite, Moriyama made a name for himself with his animation work on *Urusei Yatsura*. He directed and designed the characters for the *Project A-Ko* animated film series.

Takashi Nakamura (name)

Animator. Nakamura directed animation for *Akira* and worked on animation for *Memories* and *Noiseman Sound Insect*. He is one of the few animators working today who does character animation with strict attention to bone structure.

Katsuhiro Otomo (name)

Manga artist. Otomo first gained attention for his original manga *Domu*. Later, he catapulted to fame when he was singled out to design the characters for the full-length animated film *Harmagedon* (aka *Great War with Genma*). Currently, Otomo is active as an anime creator. His directoral credits include *Akira* and *Memories*, and he wrote the screenplays for *Roujin Z* and *Metropolis*.

Photo retouch software (term)

In simple terms, software that enables enhancement of photographs.

Rental manga (term)

Japanese manga published through the early 1970s expressly for rental purposes. These B-grade comic books were produced and published separately from manga intended for sale in bookstores, by publishers such as Uzuki and Akebono Shobo. Rental manga reached its heyday in the mid-1960s. Shigeru Mizuki, of *Spooky Kitaro* fame, got his start creating comics for rental manga.

Round pen (term)

A thin pen with a tubular-shaped round nib. Round pens have no ink cartridge and are dipped in ink. Because round pens enable uniform drawing of fine lines, they are used for detail work. However, drawing with round pens requires a high level of skill, so most artists use G-pens, which are easier to use and adapt well to drawing lines of varying widths.

Yoshiyuki Sadamoto (name)

Animator and manga artist. Sadamoto launched his career as the character designer for *The Wings of Honneamise*. He went on to establish his popularity in *The Secret of the Blue Water* (aka *Nadia of the Mysterious Seas*) and *Evangelion*. He is currently working on the character designs for *.hack*, an animation series.

Screentone (term)

Film printed with patterns of lines and dots in a complete gradation of shades from white to black. Screentone has wax or other light adhesive on the back which allows the film to be repeatedly affixed to or peeled off of drawings. Several hundred varieties of screentone, including ready-made backgrounds and decorative ruled lines, are sold in Japan.

Masamune Shiro (name)

Manga artist. Shiro came to public attention with *Appleseed*, a science fiction action manga distributed by Seishinsha. He gained international recognition in 1995 when the story was made into the animated film *Ghost in the Shell*. The film features mecha and military elements rendered in fine detail, as well as authentic action sequences.

Tablet (term)

A peripheral device that combines a drawing tablet with a stylus and graphics software. Drawing tablets enable pressure-sensitive input, and are indispensable for working in digital painting applications such as Painter.

Watercolor pencil (term)

Colored pencils with a water-soluble lead. Staedtler's Karat Aquarell pencils are well-known. Watercolor pencils are used mainly to add accent to illustrations drawn with Copic markers and watercolor ink.

The Wings of Honneamise (title)

Full-length animation film released in 1987. This was the debut film from Gainax, a company that made a name for itself with the enormously popular *Evangelion*. *The Wings of Honneamise* was acclaimed for its careful direction, richly detailed world, and elaborate rendering of mecha.

Screentone set **Tablet** **Adobe Photoshop 7.0** **Corel Painter 7.0**
Japanese version **Japanese version**

KEYWORDS

In order to understand the current tide of Japanese anime and manga,
it is essential to understand how the comic-fanatic (or "Otaku") uses various terms.
To truly understand anime and manga, it is probably more important to understand these terms
than to understand the cultural and historical background underlying Japanese illustration.
Here we describe the four representative keywords so necessary to gaining insight into Otaku.

Keyword #1: *Moe*

"*Moe*" is perhaps the most difficult term to explain in detail in order to highlight the current Japanese anime and manga culture.

The standard usage of this expression would be a statement like "I'm in XXX *Moe*" instead of saying "I like XXX." Also, when one finds a particular subject very exciting, one can say "XXX is *Moe* to me." Whereas the term was once used to represent vague and ambiguous excitement, now *Moe* is more often used as the strongest expression of one's favorite things.

In the Japanese language, words with the same pronunciation have different meanings depending on the writing system (or Kanji) used. Depending on the Kanji used, *Moe* can mean a: "burning," or b: "bud (of a plant)." The true history of the word *Moe* as slang in an anime and manga context has not been clearly identified. Some say it came from the name of a manga character. Others say that it was first used by a radio disc jockey who was popular with young listeners. But regardless of etymology, the ambiguity surrounding the word matches well the enigmatic attraction Otaku have for anime and manga.

Keyword #2: *Akiba-Kei*

Tokyo's Akihabara district is world-famous for its hundreds of appliance and electronics stores which make it a veritable mecca for visiting manga, anime, and videogame fans. When you step into Akihabara, you are deluged with gigantic images of various videogame characters peering out from every store window. Staff writers, directors, designers, and illustrators working at the forefront of the anime and manga industries routinely come to Akihabara to research the market and study what styles of artwork are currently popular. *Akiba-Kei* illustration refers to artwork featuring the subjects, figures, and expressions popular in video or computer games. The trend in adult-oriented game graphics (which Japanese call "Gal-gei") reflects the sales tendency and/or direction of these Akiba-kei illustrations.

Keyword #3: *2 Channel*

2 Channel is an internet community bulletin board that profoundly influences Japan's manga and anime industry. Basically a group of bulletin boards from many categories, such as Yahoo! or MSN Community, *2 Channel* is a free bulletin board where anybody can drop in (without revealing one's IP or host files,) and write any information or message they choose. (Participants' anonymity is usually preserved except in the case of highly insulting messages.) Unlike some other internet bulletin boards, *2 Channel* attracts users with very high media literacy. Although the information collected at this site is not verified for authenticity, *2 Channel* has become a mammoth community (with over 1.5 million accesses per day) and a locus of information unavailable from other sites.

2 Channel is acknowledged as an incredible resource, especially for marketers researching industry trends, rumors, and gossip.

Keyword #4: *Toko Corner* (Reader's Column)

Even amateur artists in Japan are well known for their high standards of skill and technique. One reason for that high skill level has to do with the existence of "Toko Corner" (or Reader's Column) pages in Japanese amine and game graphic magazines. Most such magazines encourage readers to contribute their amateur artworks, with the best submissions featured in the magazine's "Toko Corner" pages.

The Toko Corner stands as an extension of the Otaku's hobby and provides a forum where magazine editors and readers can acknowledge amateurs' work. As such, the Toko Corner plays an important role in many artists' transition from amateur hobbyists to working industry professionals.

CREDITS

Hirofumi Fujiko
p.19: Comickers magazine 2002 winter issue, Illustration Masters (Bijutsu Shuppan-sha)
p.22 #1: Digital Comickers for Beginners 1 (Bijutsu Shuppan-sha)
p.23 #2: Bloom Planet 2001 Autumn (Bijutsu Shuppan-sha)
p.23 #4: Comickers magazine Spring issue, Illustrations Masters (Bijutsu Shuppan-sha)

Nanamirio
p.27: Comickers 2001 summer issue, Illustration Masters Color Theater
p.28-29, p.30 #1: Comickers 2001 summer issue, Illustration Masters Color Theater
p.31 #2: Comickers 2001 spring issue, Illustration Masters (Bijutsu Shuppan-sha)
p.31 #4: Comickers 2001 Autumn issue Illustration Masters (Bijutsu Shuppan-sha)

Noriko Meguro
p.36 #1, p.37 #2, p.39 #7: Digital Comic Magazine 1999 (MdN Corporation)
p.38 #3: Book "Yosei Meligene" (Shakai Shiso sha)
p.38 #4: Digital Comickers for Beginners 2 (Bijutsu Shuppan-sha)
p.38 #5: Book "Higan Toshi" jacket (Keibun sha)
p.39 #6: Book "Hitokiri Kimon" (Gakken)
p.39 #8: Book "Higan Toshi" (Keibun sha)
p.39 #9: Book "Shin Megami Tensei Character Profile" (Kadokawa Shoten)

Shunpei
p.44 #1: Comickers 2002 winter issue, "NEW MINT" advertising illustration (Bijutsu Shuppan-sha)
p.44-45 #2: Comickers 2000 summer issue Illustration Masters Grand Prix (Bijutsu Shuppan-sha)
p.45 #3: Comickers 2001 autumn issue "NEW MINT" advertising illustration (Bijutsu Shuppan-sha)
p.46 #4: Comickers 2000 autumn issue Illustration Masters (Bijutsu Shuppan-sha)
p.46-47 #5: Comickers 2001 Summer issue "NEW MINT" advertising illustration (Bijutsu Shuppan-sha)
p.46-47 #6: Error #1 (Bijutsu Shuppan-sha)

Hinoki Amamori
p. 51: Comickers 2002 winter issue Art Material (Bijutsu Shuppan-sha)
p.52 #1: Comickers 2001 spring issue Illustration Masters (Bijutsu Shuppan-sha)
p.52 #4: Comickers 2001 autumn issue Illustration Masters Color Theater (Bijutsu Shuppan-sha)
p.52 #5: Comickers 2002 winter issue Illustration Masters (Bijutsu Shuppan-sha)

Sunaho Tobe
p.60 #1: "Zettai Shonen Project" image illustration (Toy's Works)
p.61 #2: Digital Comic Magazine 2001 spring issue (MdN Corporation)
p.62 #3: Colorful PURE GIRL 2002 April issue (Biblos, Inc.)
p.63 #4: "GAME SPOT" (Softbank Corp.)

nini
P.8: MajiQ PREMIUM SPRING 2002
p. 70 #3: Colorful Pure Girl 2002 June issue (Biblos, Inc.)
p. 70 #5: Colorful Pure Girl 2002 March issue (Biblos, Inc.)

Ryuya
p.91: Comickers 2002 winter issue, Art Material (Bijutsu Shuppan-sha)
p.92 #1: Comickers 2002 spring issue Illustration Masters (Bijutsu Shuppan-sha)
p.93 #2,3,4: Comickers 2001 autumn issue Illustration Masters (Bijutsu Shuppan-sha)
p.94 #5: Comickers 2001 spring issue Illustration Masters (Bijutsu Shuppan-sha)
p.94 #6, p.95 #9,10,11: Comickers 2000 summer issue Illustration Masters (Bijutsu Shuppan-sha)
p.94 #7: Comickers 2002 winter issue Illustration Masters (Bijutsu Shuppan-sha)
p.95 #8: Comickers 2001 winter issue Illustration Masters (Bijutsu Shuppan-sha)

Yoko Tanji
p.99: Mystery davinci 2002 April issue (davinci/Mediafactory)

Mey Suzuki
p.107: Colorful Manpuku Sei (Biblos, Inc.)
p.108 #1: PURE GIRL (Japan Mix)
p.108 #2: Colorful Pure Girl 1999 July(Biblos, Inc.)

Ippei Gyobu
p.116-117: error #0 issue (Bijutsu Shuppan-sha)
p.118-119: Comickers 2001 Autumn issue (Bijutsu Shuppan-sha)
p.108 #3: Colorful Pure Girl 2000 September (Biblos, Inc.)
p.109 #4: Colorful Pure Girl 1999 May (Biblos, Inc.)
p.109 #5: Colorful Pure Girl 2000 July (Biblos, Inc.)
p.110 #6: CG Hobby Vol.2 2001(San-ei Mook)
p.110 #7: CG Hobby Vol.1 2001(San-ei Mook)
p.110 #8: CG Hobby Vol.3 2001(San-ei Mook)

AFTERWORD

Illustration in Japan until twenty or thirty years ago could be broadly divided into three categories: drawings for manga stories, simplified drawings for television animation, and fashion design illustration. Traditional boundaries gradually eroded as creative artists working in the manga and anime industries began moving into other genres-animators creating illustrations for ad posters and game designers working on anime character designs are just two examples. As illustration underwent rich cross-fertilization of talent from all artistic quarters, an abundant variety of styles including realistic representation, pop art, and "stylish" drawing emerged to take their place alongside mainstream manga and anime illustration.

The rapid popularization of computers has also had a remarkable impact on illustration. Adobe Photoshop and other software applications incorporate a host of filters that make available to illustrators modes of artistic expression formerly impossible with hand drawing.

This volume presents for the reader's perusal the rich diversity of distinct styles of illustration in Japan today.

Yu Kagei imbues her elegant characters with a soft, realistic look that is unusual in the world of computer graphics illustration. Yoko Tanji's colorful illustrations are rendered with an expressive power and excellent eye for composition that belie their computer graphic origins. Noriko Meguro adds a cyber touch to her unique vision of translucent worlds. Ryuya illustrations demonstrate an exceptional feel for the exotic, coupled with fine expressive power. Hirofumi Fujiko's uncomplicated style of char-

acter drawing infused with energy and lighthearted nonchalance demonstrates outstanding artistic ability. Nanamirio is a highly unusual artist, expert at the special technique she has devised of trickling ink to achieve the effect of soft light. Sunaho Tobe's gently colored, nostalgic illustrations of likeable anime-type characters are beautifully and precisely rendered. MeySuzuki focuses on the popular combination of mecha and pretty girls in colorful illustrations that are suggestive of cel animation pictures. nini's dazzling, charming illustrations are done in a distinctive and popular style known as *moe* (after the name of a popular anime character). Hikaru Nakano's unique worlds are artfully drawn entirely with pencils in pastel colors. Hinoki Amamori uses markers to create "down-to-earth" fantasy worlds. Shunpei's illustrations display an element of unique design and a superior eye for composition and color. ridoru makes skillful use of CG filters by stacking them to lend a soft atmosphere to his her illustrations. Ippei Gyoubu creates unique pop art illustrations with Adobe Illustrator.

The artists introduced in this book have been carefully selected to represent the extensive panorama of techniques and styles prevalent in illustration today. The works of these fine artists attest to both the maturity and depth illustration has attained in Japan and the abundance of talent working in this genre. It is hoped that the reader will find great satisfaction and pleasure in this wonderful sampling of the prolific world of illustration in Japan.

Keiko Yamamoto/Editor for *Comickers* magazine

REFERENCE BOOKS

The Anime Encyclopedia: A Guide to Japanese Animation Since 1917 (Stone Bridge Press, 2001)

Translations of the terms in this book are based on:

The Chicago Manual of Style: The Essential Guide for Writers, Editors, and Publishers (University of Chicago Press, 1993)